English Medieval Tiles

ELIZABETH EAMES

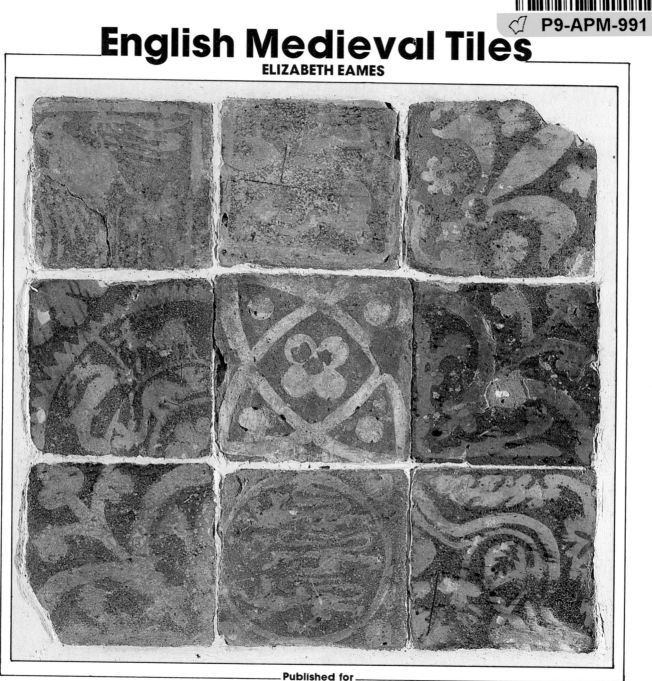

Published for
the Trustees of the British Museum by
BRITISH MUSEUM PUBLICATIONS

THE TRUSTEES OF THE BRITISH MUSEUM acknowledge with gratitude the generosity of THE HENRY MOORE FOUNDATION for the grant which made possible the publication of this book.

Front cover Part of the
decoration carried out in
sgraffito on a tile from Tring
Church, Hertfordshire,
depicting the child Jesus
miraculously repairing the
beam of a plough. One of a
series of illustrations of
stories from Apocryphal Gospels
about the childhood of Christ.
Complete tile 325 × 163 mm.
See also fig. 24, p. 23.

Inside front cover Sixteen-tile
design including the rebus of
Thomas Stafford, Abbot of
Hailes from 1483 to 1503,
present on tiles (145 – 150 mm
square) from Hailes Abbey and
Southam de la Bere. Second
quarter of the 16th century.
See also fig. 86, p. 66.

Inside back cover Sixteen-tile
design present on tiles (125
mm square) in the Canynges
pavement, now displayed in
the British Museum. 15th/16th
century. See also fig. 81, p. 64.

Back cover Part of a mosaic
arrangement of concentric
circular bands, displayed in
the British Museum,
reassembled from loose tiles
from the site of Byland Abbey,
Yorkshire, following examples
still in position there. Mid-
13th-century.

Page 1 Panel of inlaid tiles of
the 'stabbed Wessex' series
displayed in the British
Museum. These tiles were
derived from those used at
Hailes Abbey in the 1270s and
were made until the 1330s.

Pages 2 – 3 Segment of a
circular pattern from the first
floor chapel, Clarendon
Palace, built for Henry III by
Elias of Dyrham, assembled in
the British Museum from tiles
recovered during excavations
and plaster casts. 1240 – 4. See
also fig. 61, p. 49.

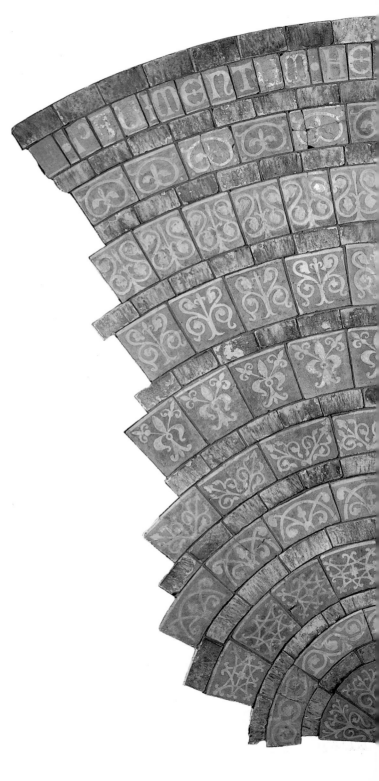

Contents

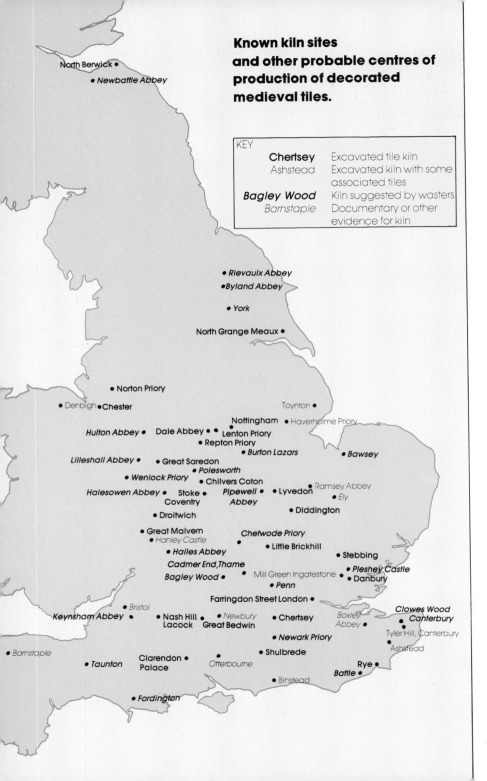

Known kiln sites and other probable centres of production of decorated medieval tiles.

KEY

Chertsey	Excavated tile kiln
Ashstead	Excavated kiln with some associated tiles
Bagley Wood	Kiln suggested by wasters
Barnstaple	Documentary or other evidence for kiln

Introduction

Decorated tiles provided a vivid patterned pavement for the floors of royal palaces, ecclesiastical and monastic buildings, and prosperous merchants' houses in the Middle Ages. Although some decorated tiles were used in England in the tenth and twelfth centuries, the period of their greatest popularity was from the thirteenth to the mid-sixteenth century. They were associated with Gothic buildings, and the remaining pavement of the chapter house at Westminster Abbey shows how the rich, warm tones of the tiles provided a colourful floor, which contrasted with the original painting and gilding of the mouldings, capitals, and walls. Decorated tiles, especially two-colour tiles, were essentially part of Gothic architectural decoration. When more Italianate architecture was introduced in the mid-sixteenth century they went out of fashion. Their place was taken by black and white stone quarries or by large plain-glazed tiles set alternately dark and light in imitation of stone pavements.

The range of designs found on decorated tiles is a notable record of Gothic minor art, and the tiles derive much of their attraction from the variety and quality of the designs used. They include foliage, geometrical forms, heraldry and heraldic animals such as lions and griffins, and more rarely figural scenes such as those illustrating the Romance of Tristram and Isolde from Chertsey Abbey. The craftsmanship involved in the manufacture of these tiles varied widely from the high levels of skill displayed in the manufacture of the Chertsey tiles to the repetitive, blurred and imprecise designs of the tilers at Little Brickhill. The craftsmen used the same clay that was used for roof

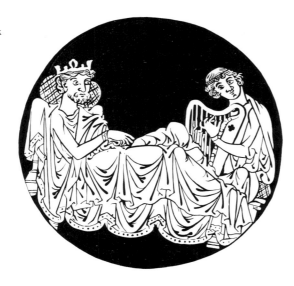

2 Design showing Tristram playing the harp to King Mark present on inlaid roundels from Chertsey Abbey, Surrey. 235 mm diam. *c.* 1260–80.

3 Detail of the 19th-century replica of the mid-15th-century paving of the sanctuary at Great Malvern Priory, Worcestershire.

tiles and glazed the tiles with a lead glaze. Various colours were produced by the use of different body clays, clay slips, inlays and glazes, but no enamel colours or paints were used. This book describes the different methods used by the medieval tilers to produce and decorate their tiles.

It is not surprising that only a small percentage of the tiles made have survived; indeed, it is remarkable that we have so many. We owe this in part to the interest taken by nineteenth-century architects and collectors, especially those associated with the Gothic revival. By the early nineteenth century many churches had had little spent on them since the Reformation and were very dilapidated. One result of the renewed interest in Gothic architecture was a vigorous rebuilding or restoration of medieval churches. This work frequently included repaving with replicas of the medieval tiles. Sometimes the medieval pavement formerly in the building was copied exactly. Good examples of nineteenth-century tile pavements that are replicas of their medieval predecessors can be seen in the sanctuary of Great Malvern 3 Priory Church and in the chapter house of Salisbury Cathedral. More often any replica tiles that were available were used whether or not they repeated the arrangement and style of the medieval floor. When any original decorated tiles survived in fairly good condition it was usual to save them. Sometimes they were laid together in one part of the new pavement, sometimes they were kept loose in the church or were acquired by private collectors. The major collections in the British Museum and in the Victoria and Albert Museum include many tiles that had been saved by private collectors. The largest collection was that amassed during the first half of the twentieth century by Captain the Hon. Charles Ludovic Lindsay and the Ninth Duke of Rutland, over 8,000 of whose tiles were bought by the British Museum in 1947. The process of removal, restoration or replacement still goes on. An exact replica of a thirteenth-century pavement was made and laid in the north presbytery aisle of Winchester Cathedral in 1969.

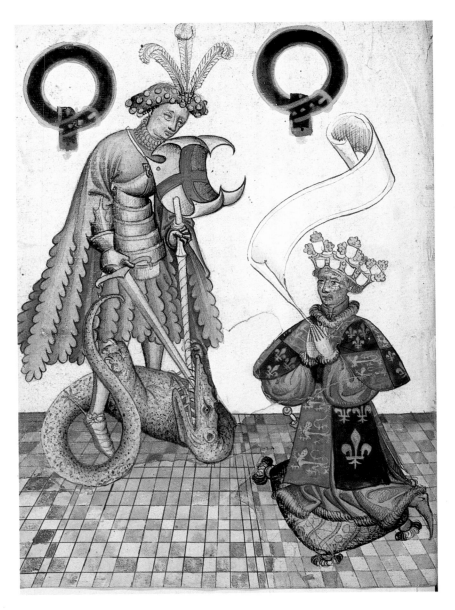

4 William Bruges, first Garter King of Arms, kneeling before St George and the Dragon, on a tiled pavement. Parts of three panels are shown, each apparently filled with arrangements of plain glazed tiles. Such pavements were common in the 15th and 16th centuries, many of the tiles being imported from the Netherlands. British Library MS Stowe 594 f. 5b. *c.* 1430.

1 The tile-making industry

Since the manufacture of decorated tiles was probably fully developed on the Continent before it was introduced to England, it seems very likely that the first English examples were made by foreign tilers. Some may have been pressed into the service of the king, others may have moved to England within their monastic order. There can be no doubt that at first all tilers worked on special commissions, making their tiles as near as possible to where they were to be used. The king's tilers in the thirteenth century were paid a daily wage and doubtless had rations of bread and beer, but by the fourteenth century they were being paid per thousand tiles, either manufactured or laid.

Some large religious houses could call upon the labour of their lay brothers to make elaborate tile mosaics. In the Cistercian houses a number of the monks themselves probably took part, not only in the organisation of the work but also in the actual making of the tiles, thus fulfilling their vows to serve God partly through manual labour.

Fortunately for archaeologists the furnace area of a kiln was usually sunk into a shallow pit, so that the surrounding ground provided insulation and support, and the oven above the furnace was accessible at ground level or only a little above it. When a kiln was no longer needed, the workers demolished it down to ground level and often filled the subterranean part of the structure with the spoil from the demolition. Because of this many furnaces have survived and we have more information about the furnaces than the ovens. Gradually more and more kiln sites are being discovered, but they are

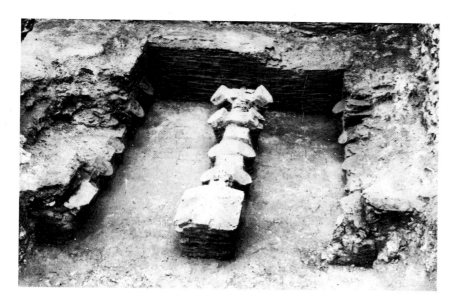

5 Furnace of a tile kiln at Clarendon Palace, Wiltshire, during excavation in 1937. 1240–4.

only a fraction of the hundreds of kilns which produced decorated floor tiles for over 350 years. The substructure of a tile kiln discovered at Clarendon Palace, Wiltshire, is illustrated and may be seen in the British Museum.

It seems likely that, although for the first decades after their introduction tiles could be afforded only by the king and the religious houses, there was a gradual increase in demand from rich magnates and wealthy merchants. They did not have the space to set up a tilery just for their particular project, so commercial tileries came into production, making tiles for many customers who paid separately for their transport by road or water. Sometimes tileries seem to have been set up for a specific commission and then run commercially after the local job was completed. Certainly after the Black Death when tilers' wages had doubled and landowners' rents had fallen almost no one could afford to

have tiles made specially for them; instead they had to buy mass-produced tiles from an established tilery. Although it was thought that commercial tileries were not established before the fourteenth century, it is now known that several were operating during the later thirteenth century, one possibly before 1260.

Archaeological evidence from a number of excavated kiln sites which have yielded more roof tiles than decorated floor tiles suggests that the maker of decorated floor tiles would sometimes join an existing tilery for roof tiles rather than set up in an entirely new location. There would be many advantages in this. The occupant of the tilery making roof tiles would own or lease clay pits and have access to a good supply of fuel. He would have premises and land on which additional sheds and kilns could be erected and he would have an organised system of distribution for his products. The maker of decorated floor tiles might stay in one tilery all his working life or he might spend a few years in one and then move on to another when demand in the area was satisfied.

The men who made decorated floor tiles were specialists, whether they were working on particular orders or for a general market. They possessed a store of knowledge about the methods of decoration, the combination of different clays, the making of glazes and the construction of kilns that would reach the required temperature, far beyond the knowledge necessary for the tiler who made roof tiles, even if he sometimes produced glazed wares. Nevertheless, it is probable that many roof-tile makers tried their hands at making decorated floor tiles. Only so can one account for the many local oddities, well out of the general trend, that are present up and down the country. Some of these were

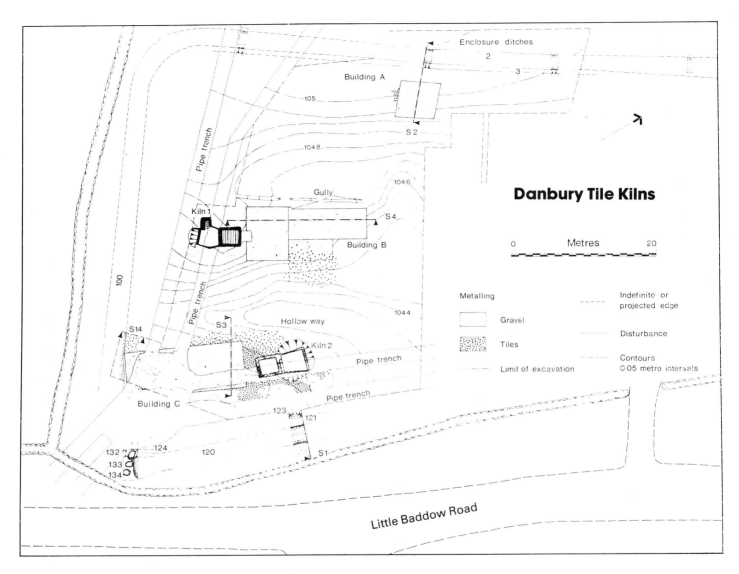

Danbury Tile Kilns

Enclosure ditches

Building A

Pipe trench

Kiln 1

Gully

Building B

Building C

Hollow way

Kiln 2

Pipe trench

Pipe trench

Pipe trench

Little Baddow Road

0 Metres 20

Metalling

Gravel

Tiles

Limit of excavation

Indefinite or
projected edge

Disturbance

Contours
0·05 metre intervals

6 Plan of the tilery excavated at Danbury, near Chelmsford, Essex, in 1974.

perhaps made to carry out repairs.

Work in the medieval tileries was seasonal. The clay received very little preparation. It was dug in the autumn and left in heaps in the open air to weather. The heaps were turned over at least once around Christmas time. Existing kilns were repaired or new ones built and tile making began in the spring. The tiler worked at a sanded board or table and shaped the tiles in a square wooden form, like a box without a base or lid. He threw a lump of clay into the form, pressed it in, cut off the surplus clay from the top with a wire bow, smoothed the top with a wet piece of wood called a strike, turned out the tile on to a pallet and set it aside to dry. Roof tiles, unglazed tiles and bricks were air-dried out of doors. There is some evidence from the excavated tilery at Danbury, near Chelmsford in Essex, that the decorated tiles were dried in a shed in which there may have been a fire to hasten the process. Methods of drying probably varied from place to place. When the tiles were leather-hard, they were returned to the bench, decorated, trimmed round the edges, and glazed. They were then ready to fire.

There were many different ways of decorating them, which will be described in detail in the following chapters. The only glaze was a lead glaze to which other metals were added to alter the colour. All medieval lead glazes contained iron impurities which added a yellow tint to the clear lead which looked yellow over a white clay, brown over a red clay and olive over a grey clay. These iron impurities were due to the way in which the glaze was made. A powdered galena, lead sulphide, may sometimes have been used but both documentary and archaeological evidence suggests that it was customary to use an ash of lead oxide. This was made by placing lead, probably scrap, in an iron pan in a furnace and raking it with an iron rake. Inevitably contamination would result. The prepared ash or powder was mixed with a liquid and brushed on to the unfired tiles. During firing the lead combined with silica and alumina in the fabric of the tiles to form a glaze and as most English clays contain iron this was another source of contamination.

Occasionally extra iron was added to the glaze intentionally to make a rich dark brown but the most usual addition to the lead was copper or brass introduced as filings. In small quantities this made a green glaze and in large quantities black. Glaze made in this way was not quite as glossy as a fully prepared glaze fired on to an already biscuit fired tile but it was very firmly bonded in to the surface of the tiles and wore well. When they were new lead glazes had a characteristic brilliance often combined with slight iridescence that enlivened the surface of the tiles particularly those decorated in relief that reflected the light in different directions.

Commercially produced tiles were adapted to be profitable, to withstand travel and to be laid by people other than those who had designed the decoration. The size was an important factor in profitability. Many of the specially designed tiles were large and thick. Some of the Yorkshire mosaic pieces were made two or three times as thick as necessary.

In the medieval period it was probably necessary to make tiles that had a large surface area fairly thick to prevent warping. The thicker the tile, the more raw material it used, the longer it took to dry, the fewer tiles would go in the oven and the fewer could be transported in one cart or boat.

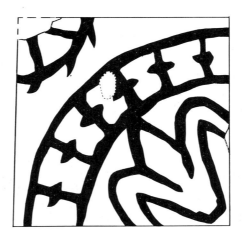

7 Three repeating four-tile two-colour designs used at the Little Brickhill kiln in Buckinghamshire. 112–117 mm square. 15th/16th century.

The producers of commercial floor tiles had to find a size that would strike a balance between economy in the use of raw material and fuel and the production of a tile that was too small and required too much labour in handling and laying. They seem to have settled on a surface area between 100 and 125 mm square and a thickness around 20–25 mm, although the thickness varies much more than the surface area, even among the products of one tilery.

We do not know the names of any of the designers who drew the decorative patterns. They probably ranged from such artists as Henry III's painters, Master William and Master Walter of Durham, to the son of the local tiler whittling out a pattern on a block of wood in the winter evenings. One suspects that every now and again, when special tiles were commissioned, a competent artist drew the designs and a competent carver cut the stamps. The artist and carver may often have been the same man, but whether he was also the tile maker is more doubtful. Once these stamps were made, they were re-used until they wore out. They were copied, and the

copies were copied, until the original design was scarcely recognisable. Besides copying existing stamps, the carver might also make more fashionable variations on the same themes: the elaboration of the fleur-de-lis as a motif demonstrates this.

It is probable that at all times, except perhaps between about 1350 and 1380, tilers could be found who would execute special orders provided the customer would pay an enhanced price. When new designs were made for such special jobs, they then passed into the common repertory, which was thus replenished. There was no copyright in a design even when it included personal names and heraldry. Probably at the same time as the Little Brickhill tilers were churning out their 7 dreary designs of catherine wheels and outlined fleurs-de-lis, someone at Hailes 8 was designing the superb Anthony Melton tiles and someone else in Yorkshire was designing the big four-tile heraldic groups for Abbot Marmaduke Huby at Fountains.

When these decorated floor tiles went out of fashion, some very specialised knowledge, particularly about the inlaying of white clay, was lost and has proved very

difficult to recover, as many potters and art students who have experimented in inlaid decoration have discovered. The work of Loyd Haberly and Professor Baker, and of members of the staffs of various art departments in schools and colleges who have made controlled experiments, has been particularly valuable. It is to be hoped that such experiments will continue to be carried out and published, because only by such experiments can it be proved whether or not our theories about the methods used by medieval tilers in the manufacture and decoration of their products can be carried out in practice.

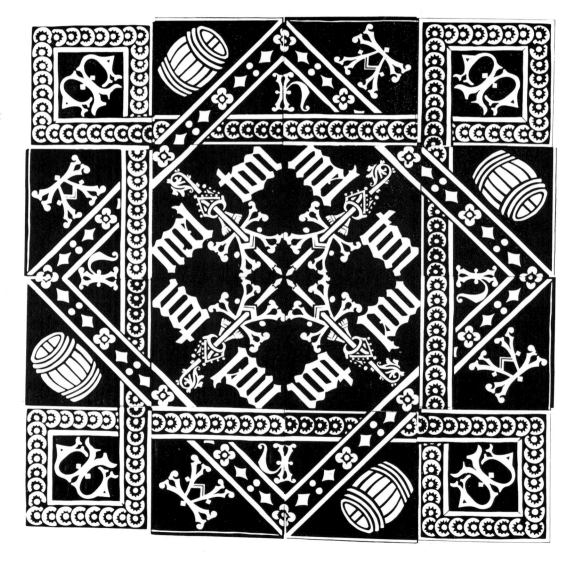

8 Sixteen-tile design including the name, initials, rebus and insignia of Anthony Melton, Abbot of Hailes, Gloucestershire, from 1509 to 1527. Each tile 150 mm square.

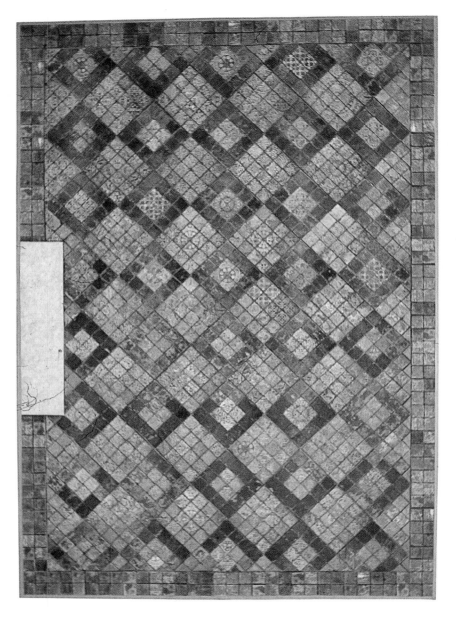

9 Complete pavement from Canynges House, Redcliffe Street, Bristol, probably laid between 1480 and 1515. All the tiles have opaque patches on the surface, caused by tin in the glaze, and can be regarded as seconds. Now displayed in the British Museum.

2 Tile pavements

A few pavements still remain in position with their original arrangement and with the decoration on their tiles relatively unworn. A number are in treasuries or muniment rooms to which only a few people have had access and where parts of the floor have always been covered by chests and presses. Others were for some reason covered by another floor before they had had much wear. The pavements in treasuries, muniment rooms and private libraries such as those in the Aerary, Windsor Castle, the muniment rooms of Westminster Abbey and Salisbury Cathedral, and the treasury of New College, Oxford, are still not generally accessible to the public.

The pavement in the chapter house at Westminster Abbey was covered by a board floor which was removed when the building was restored by Sir George Gilbert Scott during the 1860s. Some restoration with specially made replica tiles was necessary, but most of the tiles are still the thirteenth-century originals. At the time of writing, the chapter house is in the care of the Commission for Historic Buildings and Monuments and is open to the public. The splendid complete pavement from a private house in Bristol, Canynges House, was also covered by a wooden floor. This pavement was removed in 1913 and is now displayed in the British Museum. Two pavements found in Clifton House, King's Lynn, in the 1960s had been covered by another tiled floor.

Three elements are present in the design of a tile pavement: first the division of the area into panels, secondly the arrangement of tiles within each panel, and thirdly the decoration on the surface of individual

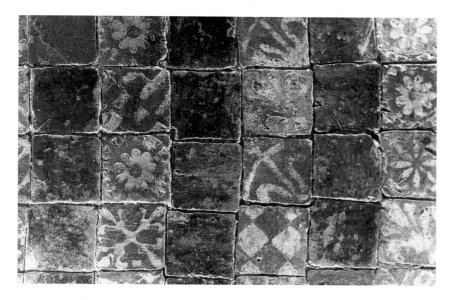

tiles. Generally the panels into which the floor was divided were long and narrow and ran parallel to each other down the length of the room, as was the arrangement in the chamber at Clifton House, King's 10 Lynn; sometimes similar panels ran across the width of the area as in the north presbytery aisle in Winchester Cathedral, and the small area of paving from the Queen's Chamber at Clarendon Palace now displayed in the British Museum. Occasionally a more elaborate layout was arranged such as that in the muniment room at Salisbury Cathedral where the panels are arranged in a cross and triangle shape that fits the octagonal plan of the building, and in the chapter house there 11 where this more complicated plan was used and is still followed in the replica pavement. At Westminster, however, where the chapter house is the same octagonal shape but two or three decades earlier, the panels are arranged in simple parallel strips running west to east, except for one north-to-south panel in front of the stone bench at the east end where the abbot and principal officials would sit when they were present at the daily meeting.

The panels were separated from each other by narrow borders, sometimes only one tile wide. The tiles in these borders were often plain glazed tiles without other surface decoration, although decorated tiles were occasionally included.

A single panel might be filled with tiles

10 *above left*. Detail of the pavement in the chamber of Clifton House, King's Lynn, Norfolk. 13th/14th century.

11 *left*. Henry Shaw's colour plate, published in 1858, showing the arrangement of the 13th-century pavement of Salisbury chapter house repeated in the 19th-century replica now present.

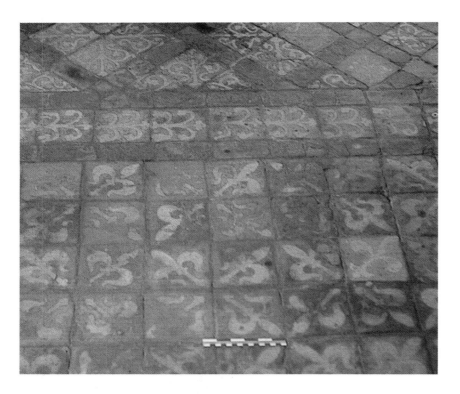

12 Detail of the 13th-century pavement of inlaid tiles in the retro-choir of Winchester Cathedral.

which were all decorated with the same design on the surface. The panels in the north presbytery aisle at Winchester were laid in this way, but further east in the 12 retro-choir, where many of the original tiles are still in position and the original layout is preserved, some panels have a more complicated arrangement in which groups of four tiles with surface decoration are surrounded by undecorated tiles with a dark glaze. This scheme is also present in two panels in the Queen's Chamber pavement from Clarendon Palace. Sometimes panels were filled entirely with plain tiles glazed in contrasting colours and arranged in simple patterns within the panels.

In any of these methods of filling the panels the tiles could be set in two ways, either square to the sides of the panel or diagonally. The Queen's Chamber pave-13 ment from Clarendon Palace includes one panel filled with tiles of the same design set square, one with groups of four decorated tiles surrounded by plain dark glazed tiles set diagonally, and another with groups of four decorated tiles surrounded by plain dark tiles set square. A comparable series of arrangements can be seen in the north part of the retro-choir at Winchester and in the old refectory at Cleeve Abbey in Somerset, now in the care of the Commission for Historic Buildings and Monuments. All the examples mentioned date from the thirteenth or early fourteenth century and it is possible that later the division into panels was abandoned.

The pavement from Canynges House, Bristol, is laid in groups of sixteen tiles set diagonally, covering the whole floor. Groups of sixteen decorated tiles alternate with groups of four decorated tiles surrounded by twelve plain black glazed tiles. The whole floor was treated as one panel framed by a double row of plain brownish glazed tiles beside the walls of the room. This same arrangement is present in the sanctuary of St David's Cathedral in Dyfed, where the tiles are decorated with many of the designs used in the Canynges pavement.

The pavement in front of the high altar in 14 Gloucester Cathedral, securely linked to Abbot Sebrok by the inclusion of his name and the date 1455 in one of the decorative designs, is laid in a similar way. An area of paving found at Thornbury Castle in 1982 was arranged in the same way with tiles designed for Edward Stafford, Duke of Buckingham, before his execution in 1521. This suggests that this arrangement was in use for at least sixty years.

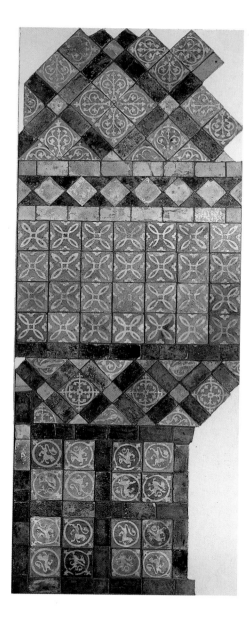

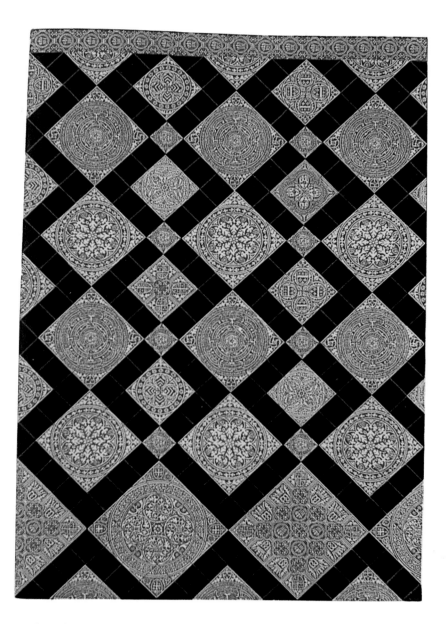

13 Remains of a pavement of inlaid tiles (140–145 mm square) from the ground floor of a chamber block built at Clarendon Palace, Wiltshire, for Queen Phillippa by Elias of Dyrham. Reassembled and displayed in the British Museum. Except in the centre panel most tiles are in their original position. 1251-2.

14 Colour plate illustrating part of Abbot Sebrok's pavement in front of the high altar in Gloucester Cathedral, published by Henry Shaw in 1858.

3 Plain tile mosaic

The beauty of plain tile mosaic lay in the combination of different tile shapes with alternating coloured glazes which brought vividly to life the geometry of the design. Within the same floor panels of contrasting circular and linear arrangements were placed together with dramatic effect.

Plain tile mosaic is thought to have been developed in western Europe in imitation of Italian stone mosaic floors. The earliest known use in England was at Fountains Abbey in Yorkshire where it was being made between 1211 and 1247. The task of paving the large church was very great and probably took many years. Finds made during excavation have suggested that the nave was paved with small tiles about 50 mm (2 in) square, dark glazed tiles being arranged in geometric patterns in a background of light glazed tiles. More elaborate patterns were included in the eastern part of the church and a selection of these were reset in a large panel on the site of the high altar in the eighteenth century where they can still be seen. These are now very worn and only a few scraps of glaze remain, but loose tiles in the museum at Fountains and in the British Museum show that the dark glaze was almost black, and the light was a greenish yellow.

Comparable tiles are still present in the 15 church of Byland Abbey, Yorkshire, where much of the paving in the eastern arm and south transept is still in position. This too is very worn, but the tiles facing the risers of the steps retain their coloured glaze and enable one to imagine the original colours of the rest. Part of a large panel almost 2 m (6 ft 6 in) square containing a circular pattern of concentric bands of mosaic and *back cover* plain dark glazed tiles was re-assembled from loose tiles by the Ninth Duke of Rutland; it is now displayed in the British Museum tile room. Many of the tiles retain some or all of their glaze and demonstrate that the colours were rather different from those at Fountains Abbey, the dark tiles being a rich, streaked green and the light a clear yellow. This arrangement is present in the north chapel of the south transept at Byland Abbey, at the north end of the high altar, and in an incomplete state elsewhere in the church. At least one example was carried out in the reverse colours of those illustrated here. The complete panel still *in situ* in the south transept chapel is made up of 906 individually cut tiles of forty different shapes, all but two of them being curvilinear. Even in the elaborate area of paving in the transept a large number of simple rectilinear shapes were used in the arrangements.

Comparable pavements were laid at other Cistercian houses in Yorkshire. The site of Meaux Abbey has yielded the 16 greatest number of different arrangements but nothing is to be seen on the site. The areas that were found in position during excavation were reburied and the disturbed tiles were removed. Parts of over fifty different arrangements are now in the British Museum. It is fortunate that the site of the kiln in which this mosaic was fired was found in 1932 and excavated in 1958. Although no part of the structure was found in position, the scattered remains were sufficient for a reconstruction to be suggested, including the specialised oven furniture needed to support the curvilinear shapes during firing.

Examination of the tiles from the site of the abbey church and the waste tiles from the kiln site provided a clear picture of the way in which they were made. A slab of clay was rolled out on the sanded forming

15 The south transept chapels at Byland Abbey showing the mid-13th-century plain tile mosaic in position.

16 Reconstruction of a circular arrangement of plain tile mosaic drawn by G.K. Beaulah, based on tiles recovered during excavation of the site of Meaux Abbey church. 1249-69.

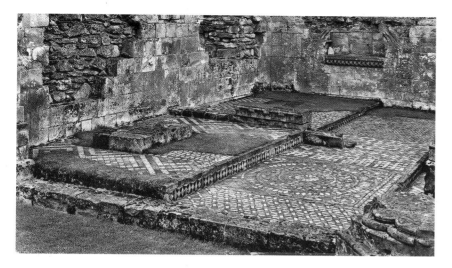

table. Templates of the various tile shapes were placed on the surface of the slab and a line was scored round them, either with a stylus or the point of a knife. These shapes were then cut out of the slab. Very occasionally the cut did not coincide exactly with the scored line which remained visible on the surface. The sides of the shapes were then pared down at an angle so that the base was smaller than the top. As a result the sides were roughly faceted. Large numbers of small square tiles were cut to shape in the same way before they were fired, and a small circular hollow, known as a key, was scooped out of the middle of the base with the point of a knife. This helped the tile to dry more quickly and evenly and provided a better bond with the mortar bed in which the tiles were laid. No other shapes at Meaux were treated in this way nor was the base of the tile trimmed, and traces of sand from the forming table are still present. Medieval tile makers seldom did trim the base, which was not seen when the tile was in use, although they frequently did make keys by scooping or stabbing holes in it.

The Chronicle of Meaux Abbey written by Thomas de Burton, a retired abbot, records that the church was paved during the abbacy of William, who ruled the house from 1249 to 1269. No other pavement was found during the excavations and there is no doubt that the tile mosaic is Abbot William's and that it was in use until the dissolution of the monastery. This would account for its very worn condition. The glazes were black and a light yellow but very few tiles retain any glaze on the surface.

Areas of comparable paving are present in the abbey church at Rievaulx where the tiles closely resemble Byland examples. Those in the church can be seen in the

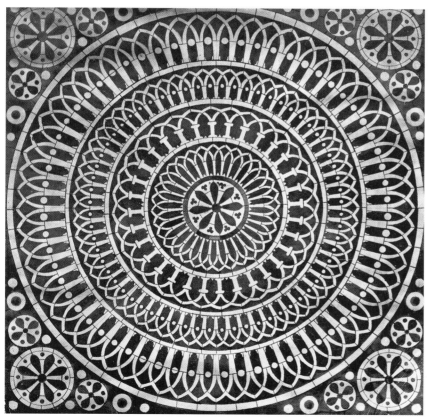

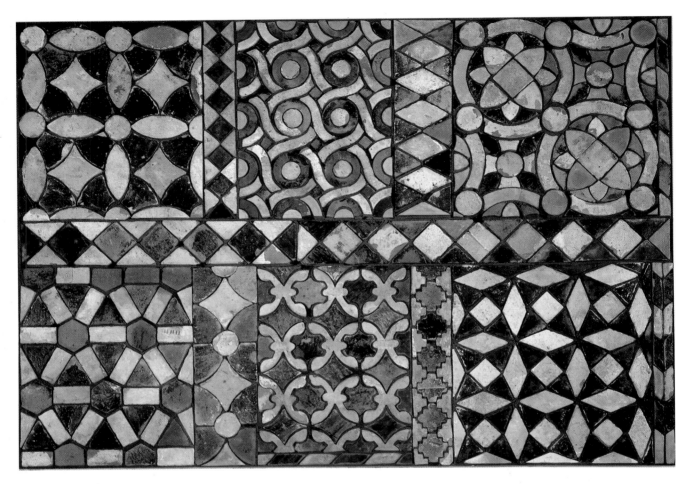

17 Plain tile mosaic displayed in the British Museum, assembled from tiles from the site of Rievaulx Abbey, Yorkshire, arranged to display a wide variety of panels and borders.

17

summer when they are uncovered, and others are displayed in the site museum and the British Museum.

The use of the same arrangements in identical form at a number of different places indicates that the same templates for the component shapes were used, but the fact that the fabric of the tiles and the glazes differ from place to place suggests that the templates were passed round rather than that tiles for different sites were made at the same tilery. When the same basic arrangement is present in a slightly

different size or with a different number of components a different set of templates must have been used. The templates themselves were probably made of copper or lead sheet; both metals were present in the tileries for use in the glaze. Copper sheet would be more satisfactory because lead sheet bends so easily. It is unlikely that a template will ever be found because once it was obsolete the metal would be reused for other purposes, but the marks of the sharp corner or edge of such a template are sometimes present on a tile, where the tiler

put it down on the slab in the wrong place or pressed it lightly by mistake before it was in position.

Later in the thirteenth century a different type of plain tile mosaic was made, closely related to French material in the Paris region. The characteristic of this type is that the mosaic shapes were not cut out before they were fired but were scored on the surface of tiles of uniform size about 120 mm (4¾ in) square. The shapes were separated after the tiles had been fired, probably by placing the tile face down on a board, placing another board or bat on top of it, and striking it one sharp blow with a mallet or hammer. The pieces generally severed along the scored lines but sometimes broke in the wrong place. The advantage of being able to fire the tiles in squares of uniform size clearly offset the loss through wastage of the pieces that failed to break along the scored lines. This same method of scoring the tiles before they were fired and separating them afterwards was used to provide the triangular halves that were needed at the edge of panels in which the tiles were set diagonally, and to provide oblong halves and small squares to frame groups of decorated tiles within a panel in arrangements such as those in some panels in the retro-choir of Winchester Cathedral and in the pavement from the Queen's Chamber, Clarendon Palace.

The small area of tile mosaic remaining in the east end of the Corona of St Thomas in Canterbury Cathedral, formerly thought to date from about 1220, has now been shown to be of this later type, and that in the north choir transept at Rochester is the same. No curvilinear shapes are included in these pavements. At both sites the glaze has worn off except from the very edge of the paving against the wall where enough remains to show that it was black and yellow. At Canterbury the fabric of the tiles is a light stone colour similar to that of the French examples and these may be imported, but at Rochester the fabric is an ordinary red earthenware more likely to be local. In a replica of this pavement, laid in the presbytery in the nineteenth century, all the component tiles are red because the designer had not realised that they were originally covered with coloured glaze. The mosaic panels are combined with panels of square tiles with surface decoration. This is characteristic of the use of this mosaic in France and was also present in Canterbury. There, although the mosaic tiles look French, the decorated ones are of local manufacture from Tyler Hill to the north of the city.

The production of pavements laid with mosaic was always a slow and difficult task compared with that of paving with uniform squares because of the shaping, handling and laying of so many small pieces. Even this simpler type of mosaic was probably more labour intensive than paving with standard square quarries because although the tiles were all fired in the parent squares, these had to be separated afterwards, and the laying of the small pieces was a slower and more expert job. There is no indication that it became widespread.

Mosaic arrangements in which surface decoration was applied to some or all of the components were being made at the same time as the plain mosaics. Except in a few rare instances specially shaped .tiles were not made after the middle of the fourteenth century.

4 Decorated tile mosaic

The same methods were used to apply surface decoration to mosaic shapes as were used to decorate square tiles. The most elaborate form of decorated tile mosaic pavement was an *opus sectile* in which large figures were depicted in rectangular panels. These figures were built up from a number of pieces of different shapes and the alternation in colour was between the figure and the background, usually a light figure on a dark background. In Prior Crauden's chapel, Ely, panels of such *opus sectile* are present in the line-impressed mosaic pavement.

18 The main panel before the altar in Prior Crauden's chapel portrays Adam and Eve and the serpent in the tree, a popular biblical theme carried out in an unusual medium. In the rest of the sanctuary and in rows at the east and west end of the body of the chapel are fifteen panels of lions and 19 two with mythical beasts. Six different lions are present being sinister and dexter versions of three forms. The separate pieces, both of the lion and the background, were all cut out round a template before they were fired, and in all examples of each form the individual shapes are identical. The templates were flat sheets that were used both ways up to produce dexter and sinister versions of each lion. The lions were yellow in colour on a black background.

In addition to the shapes of the figures, surface decoration was added. The lions had dark brown eyes and tongues, made by scraping away the white surface slip from these areas and inserting a red slip which became a dark brown when glazed and fired. The other features were depicted in lines that went through the white slip to the tile body, and the joints and locks of hair were shown in the same way. It is probable that these details were scored through slits in the template and then incised by hand but, unfortunately, the lions are so worn that most of this surface treatment is lost and it is difficult to make comparisons between one example and another. No additional decoration was added to the black tiles forming the background of the panels.

20 The Adam and Eve panel had even more elaborate treatment. Four colours were employed: the bodies are yellow, the hair brown, the leaves of the tree a light olive green and the background black. The eyes were treated in the same way as the eyes of the lions and surface detail was added by scored lines. A few pieces of another example of this panel were recovered during excavations on the site of Old Warden Abbey, Bedfordshire, and these demonstrate that templates had been used to delineate the shapes in this panel too. The *opus sectile* found there was not laid

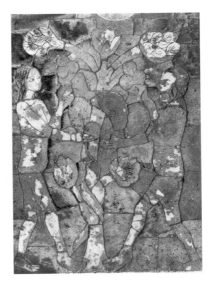 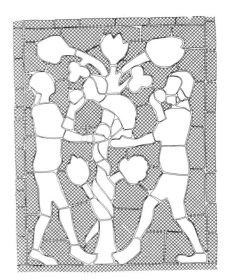

18 The panel of *opus sectile* (1.15 × 0.85 m) depicting the Fall, in front of the altar in Prior Crauden's chapel, Ely: *(left)* photograph of the panel; *(right)* diagram of the shapes from which it was assembled. *c.* 1324.

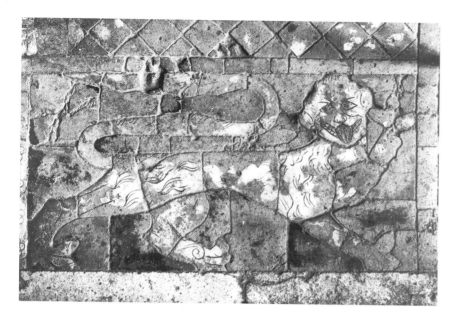

another type of decoration that I have termed 'pseudo-mosaic'. Individual tiles were treated in various ways to look as if they were made up of two or more separate tiles. The borders along the north and south sides of Prior Crauden's chapel include both lozenges and square tiles where the decorative yellow design of a lion, bird or stag on a brown tile is [21] surrounded by an impressed line to make it look like a separate yellow mosaic piece set in a brown background, as if it were a small version of the *opus sectile* lions. The alternation of light and dark elements is

19 An example of the large lion passant gardant sinister from the *opus sectile* panels of lions in Prior Crauden's chapel, Ely. 900 × 500 mm approx. *c.* 1324.

as panels, but as a random border round the edge of a room in a domestic building that had been paved entirely with oddments, presumably left over from more important pavements in the church or chapter house. The tiles were removed, and a thorough study by Evelyn Baker has revealed that the pieces of the *opus sectile* were not only marked with assembly marks but named in Latin words scored on the sides before they were fired.

Although such elaborate panels requiring individual hand work on the components were obviously labour intensive and costly, many more of them were probably made than have been recovered or identified. Until the archaeological excavations at Norton Priory, Runcorn, and Old Warden Abbey were undertaken in the late 1960s and early 1970s, the panels at Ely were thought to be unique.

Associated with the *opus sectile* and the contemporary line-impressed mosaic is yet

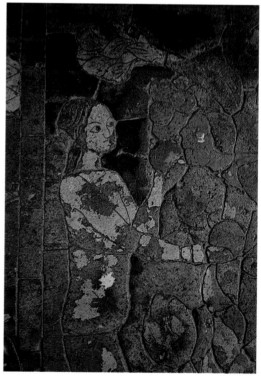

20 Detail of the panel of the fall in Prior Crauden's chapel showing Eve and the serpent. *c.* 1324.

21 Examples of the pseudo-mosaic lion and stag tiles (150 mm square) in Prior Crauden's chapel, Ely. *c.* 1324.

22 Panel including pseudo-mosaic stars and line-impressed decoration in the sanctuary of Prior Crauden's chapel, Ely. *c.* 1324.

the same as in the early plain mosaic. Another type also present in the same borders at Ely includes lozenges and squares scored with impressed lines to look as if each tile was a group of smaller tiles. The element of alternating colour is absent as each tile is a single colour. More elaborate examples, present in the sanctuary of Prior Crauden's chapel, and also found at Old Warden, are five-sided figures 22 scored to look as if they are made of seven tiles all of one colour but, in addition, having the central area cut out and a small tile of the opposite colour inserted. At Ely the large tiles are black with a yellow tile inserted. Square tiles scored to look like eight black tiles with a yellow tile inserted in the middle are present at Higham 23 Ferrers, Northamptonshire, where there are also pseudo-mosaic lions and stags, and scored squares and lozenges. The scored tiles are present at many other sites including Pipewell Abbey, Northamptonshire, and Elstow Abbey, Bedfordshire. At Norton Priory, square black tiles without scored lines but with the central area cut out and a yellow tile inserted were found in association with a kiln.

There can be little doubt that these elaborate panels of *opus sectile*, the pseudo-mosaics, and the line-impressed mosaics and line-impressed squares associated with them, were all part of a contemporary scheme of fairly expensive paving in use by about 1300 and probably not made after the Black Death.

A group of tiles from Tring, Hertford-shire, dating from the same period, might be thought of as a pseudo-mosaic although the technique used to produce it differs from any yet described. On these tiles the whole surface was coated with white slip, the decoration was outlined by incised lines, and the slip was removed from the

background with a small gouge leaving the yellow decoration separated from the brown background by an incised line. Marks of the gouge can be seen on the brown background. None of the tiles had been walked on in a pavement but were probably used as a frieze. They were decorated with figure scenes illustrating stories about the childhood of Christ from 24 Apocryphal Gospels popular at the time. The pictures are simnilar to illustrations in a manuscript now in the Bodleian Library but are not direct copies of them. Ten complete tiles and a few fragments are known.

This technique known as *sgraffito* depended entirely on hand work and would therefore have been expensive. It was used

24 Part of the decoration carried out in *sgraffito* on a tile from Tring Church, Hertfordshire, depicting the child Jesus miraculously repairing the beam of a plough. One of a series of illustrations of stories from Apocryphal Gospels about the childhood of Christ. Complete tile 325 × 163 mm. Earlier 14th century. See also front cover.

23 Pseudo-mosaic tiles on the sanctuary steps in the collegiate church at Higham Ferrers, Northamptonshire, probably set facing the risers in the second quarter of the 14th century and reset in the 19th century.

in France to decorate tomb slabs which were individual items. The tiles from Tring may have been made in France. The eight tiles in the British Museum were saved by the incumbent of Tring when they were found during building work in the mid-nineteenth century, and the two in the Victoria and Albert Museum were saved by a local resident. On such chances has survival depended even after discovery.

5 Relief and counter-relief decoration

Unglazed tiles with surface decoration in relief or counter-relief, either stamped or moulded, were made in Europe particularly in the Rhineland at least as early as the twelfth century. There is no evidence that these were used in England, but glazed tiles decorated in relief or counter-relief were used for longer than any other medieval type. The decoration was applied with a wooden stamp after the tiles had been formed and air-dried until they were leather-hard. If the decoration was to be standing above the surface of the tile in relief, the design was scooped out of the wooden stamp; if it was to be sunk below the surface in counter-relief, the background was cut away on the stamp leaving the design projecting. The same combinations of glazes and slips were used as on plain glazed and mosaic tiles to produce tiles that were each a single colour. Yellow, black, dark green, light green, olive green and brown tiles were made, of which yellow, black and dark green were the most usual. This type of decoration had a long life. Excavations carried out in the 1970s on the site of the chapter house at St Albans Abbey demonstrated that the relief-decorated tiles with which it was paved date from the twelfth century and medieval-type tiles decorated in relief were still being made at Barnstaple in north Devon at least as late as the first decade of the eighteenth century. Although this type of decoration was used for such a long time, it was never the most popular during the medieval period, and seems to have been more widely used in eastern England, where contact with the Rhineland was closest.

When relief decoration was first used the stamps were rather elaborately carved with considerable detail within the cavities, that resulted in modelling and smaller detail within the main decorative designs. This is present on some examples from St Albans, and a comparable high moulded relief was also used on the post-medieval examples from north Devon. Such rounded, modelled relief required skill in the carving of the wooden stamp with which it was applied. During the fourteenth and fifteenth centuries the stamp was usually carved more simply with flat bottoms and straight sides to the cavities, and a flat top

25 *above (top)* Three tiles decorated in relief, now in the British Museum, found during excavations on the site of St Albans chapter house in 1972. 230 mm square approx. Later 12th century.

26 *above (bottom)* Two designs based on the Pascal Lamb, carried out in high modelled relief, on tiles in the British Museum from Whitland Abbey, Dyfed, and Swineshead Abbey, Lincolnshire. 180 and 200 mm square.

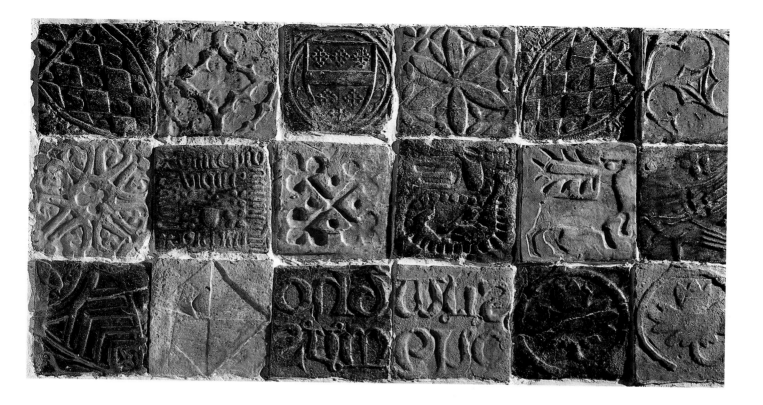

27 Panel displayed in the British Museum set with tiles decorated in relief or counter-relief from the waste heaps of the tilery at Bawsey, near King's Lynn, Norfolk. Latter half of the 14th century.

so that the resulting decoration was on two planes only and all its surfaces were flat.

It is not known how early relief-decorated tiles were mass produced. The best-known commercial tilery, at Bawsey near King's Lynn in Norfolk, was working in the last quarter of the fourteenth century. One design used there included an inscription asking for prayers for the soul of the Vicar Nicholas de Stowe whose will was proved at Norwich in 1376. The stamp was probably carved in that year to decorate tiles to cover his grave or surround his tomb in Snettisham Church where he is known to have been buried. It is unusual, and very helpful, to have such detailed information about the date of a design. The Bawsey tilery may be assumed to have

been working in 1376, but it is not known for how many years before or after that date it was making decorated tiles. The products of the Bawsey kiln were widely distributed in the hinterland of the Wash.

The priory at Castle Acre, Norfolk, used Bawsey tiles and when some were uncovered in position in the chapter house in 1840 they were found to be laid in regular groups of four tiles of the same design and colour set in a background of plain glazed tiles. The glazes used at Bawsey were dark green and yellow. A panel of Bawsey tiles is displayed in the British Museum. It includes sixteen different designs arranged in alternating colours to demonstrate the chequered effect that could be achieved with these monochrome tiles.

28 Three designs used on tiles at the Bawsey kiln: (*from left to right*) an inscription, *Pray for the soul of Nicholas de Stowe, Vicar*, who died *c.* 1376; false heraldry derived from a shield bearing three crescents; shield blazoned with a maunch (a sleeve), the arms of de Toesni of West Acre, Norfolk. 100 mm square.

One design in the panel that was also present at Castle Acre is simply the name Thomas with the letters arranged in two rows of three, but whoever carved the stamp forgot that the decoration would come out in reverse on the tile and carved Thomas as it is written. As a result the decoration on the tiles is a mirror image of the name. Whoever carved the Nicholas de Stowe design remembered to carve the mirror image so that the inscription is the right way round on the tiles. It was also important that designs including heraldry should be carved in reverse if they were to be correct on the tiles. Sometimes this was forgotten with the result that shields with the charge reversed are fairly common. The Bawsey designs include three versions of the arms of England, all with the lions sinister instead of dexter. Thirteen other known designs from the Bawsey tilery include heraldic shields, but on at least two the charges are not correct heraldry and on others they are inaccurately reproduced. One might think that heraldry would help to identify and date the tiles but generally it is the other way round, and the heraldry can be identified from the place and date of the tiles on which it is found. This is because it is so often inaccurate and there is never any indication of the all-important tinctures. Care

must always be taken about drawing conclusions from heraldry on tiles unless there is some supporting information. Once a stamp had been carved and the original order fulfilled the tilers could and did go on using it to decorate tiles which they sold to all and sundry. Thus the design made for the burial place of Nicholas de Stowe at Snettisham has not been found there but has been found at three other Norfolk churches that were unconnected with him, as well as in the waste heaps on the site of the tilery.

So much material survives from the Bawsey tilery and so much information can be derived from it that it has been described at length, but many other places were producing relief-decorated tiles. Two such tileries are known from the early sixteenth century. One was at Burton Lazars in Leicestershire in the precincts of the great leper hospital. An area of paving was found *in situ* in 1913 and is now in the British Museum, but there was no trace of associated walls. The decoration on the tiles is in relief or counter-relief and includes some heraldry. Areas of green, brown and yellow glaze are present but the surface of most of the tiles is a matt buff to khaki, because the firing temperature in the kiln had not been quite high enough for the constituents of the glaze to melt and combine to form a glass. Refiring of fragments of the same tiles from the site produced a glaze but showed that the body clay has a rather low melting-point. It was therefore difficult to strike the balance between the temperature at which the glass formed and that at which the body began to vitrify. All the tiles in this paving can be regarded as waste quality through faulty glaze, but nevertheless they had been used.

The exploration of the site uncovered

29 Detail of a piece of paving displayed in the British Museum, found on the site of the leper hospital at Burton Lazars, Leicestershire, in 1913. Decoration is in relief or counter-relief. All the tiles are faulty because the temperature in the oven was not high enough to melt all the components of the glaze. 15th/16th century.

30 Two designs which include a date, used on tiles decorated in relief made in North Devon, probably at Barnstaple, in the 17th and 18th centuries. 150 and 143 mm square.

large numbers of comparable waste tiles, an area of man-laid clay, and two small sub-circular kilns. These were not tile kilns but might have been used for the preparation of glaze. There can be little doubt that this was the working area of the tilery although the main kiln was not located. Tiles decorated with the designs present at Burton Lazars were recorded in the great parish church at Melton Mowbray in the last century. All recent efforts to find them have failed, so it is not known whether they were actually made at Burton Lazars, nor whether they had been glazed successfully.

Another sixteenth-century tilery has been located in the precinct of Ramsey Abbey in Cambridgeshire and the site was excavated by the author. The products were mainly roofing tiles. Vast quantities of waste tiles and ash were recovered, but the only kiln found was a well-preserved brick kiln securely dated to the decades immediately preceding the dissolution of the abbey in 1538. Waste paving tiles decorated in relief have been recovered from the site, only one of them during the excavations. These suffered from the same defective, underfired glaze as those just discussed from Burton Lazars. Experiments showed that this was again due to the low melting-point of the body clay, making it unsuitable for use with the contemporary lead glazes.

Lead-glazed tiles decorated in relief continued to be made in north Devon long after they had gone out of fashion and production elsewhere in England. It is certain that the industry was allied to the flourishing local pottery industry. The earliest datable tile of the type includes the date 1615 in its design and the latest includes the date 1708. It is unlikely that these two were the first and last products and we can assume that these tiles were

being made on and off for about a hundred years.

The local fabric is rather coarse, producing an open body, and most of the decorative motifs are bold, since fine decorative detail can only be achieved with a fine body clay. Some fairly elaborate designs with renaissance motifs were produced but the commonest motifs were rosettes and fleurs-de-lis. The fleurs-de-lis were sometimes flanked by initial letters or the figures of a date. No initial letters have yet been linked with any known person but the dates are invaluable. The earliest dated design consists of the date 1615 and the word 'Caricfargus'. A complete example has been in the British Museum for many years and numerous fragments were recovered during excavations at Carrickfergus, County Antrim, in the 1970s. The appearance of these tiles and the close links between the north Devon potteries and Ireland at that period have led to the assumption that the Carrickfergus tiles were products of the north Devon industry.

Only a clear lead glaze was used, no lead-copper glaze and no slip, so there are no green or yellow tiles. Many of the tiles have a reduced grey body over which the glaze looks olive, some are oxidised and therefore brown. The general effect of the surviving pavements is of a light to dull olive green. A number of churches in north Devon and Launcells in Cornwall retain areas of this paving either in position or relaid.

The only known wooden stamp for decorating tiles is associated with this industry. It was found when North Walk Pottery, Barnstaple, was being demolished at the beginning of the twentieth century and was given to the British Museum in 1906. It is most informative. There is a large

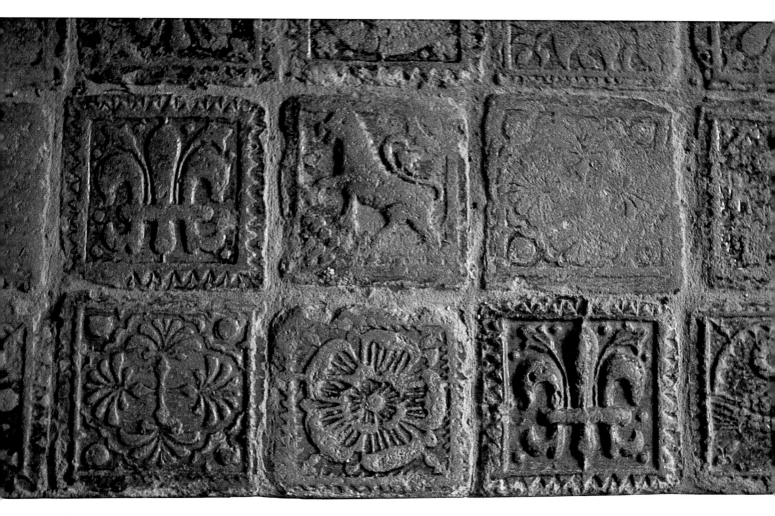

31 Detail of the pavement of relief-decorated tiles of the North Devon series in the sanctuary of Launcells Church, Cornwall.

circular compressed area in the back demonstrating that the stamp had been struck on the back to transfer the decoration to the tile. This was probably done by putting the stamp face down on the tile, placing a round headed wooden mallet on top of the stamp and striking the mallet one sharp blow with a hammer. The decoration was therefore stamped not moulded as has sometimes been suggested. Fortunately the British Museum possesses a tile decorated with this stamp, and a comparison of the size of the tile with the size of the stamp, and the known rate of shrinkage of the clay, proves that the design had been stamped after the tiles had been dried and were ready to fire. No stamp with a handle on the back could be used in this way: far more than hand pressure would be required to impress the design in the surface of the leather-hard dry tile and any projection on the back

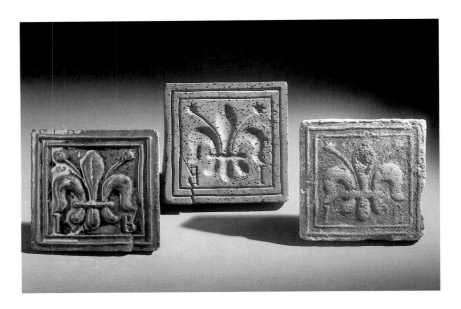

32 The only known wooden stamp (*centre*) for decorating tiles, found during the demolition of North Walk Pottery, Barnstaple, given to the British Museum in 1906. Photographed with a worn tile (*right*) decorated with this stamp when the tilery was in production and another (*left*) made when the stamp was found.

would deflect the blow and probably break off. Some stamps with handles have been considered as possible tile stamps but they could not have been used in this way.

One corner of the stamp from North Walk had split and had been repaired by the insertion of a large hand-made iron nail through the side. Splits resulted from the repeated blows on the back and are known to have occurred sooner or later in many medieval tile stamps. When a split stamp was used surface clay from the tile penetrated the crack and remained upstanding after the stamp was removed, resulting in a ridge that broke the continuity of the decoration on the tile. Continued use steadily enlarged the crack, and wider and longer ridges were therefore left on the tiles. It is sometimes possible to trace the progress of a crack in a stamp and to ascertain the order in which surviving tiles had been decorated with it. When such tiles have been found at different places it

is possible to determine the order in which these places had been paved. Sometimes the stamp became unusable while the tiles for a single site were still being produced and a new one, always slightly different, had to be carved.

The North Walk stamp covered the whole surface of the tile and all the decoration was applied with it at a single blow. This method was the most economical of time and had the best results. It was, however, possible to use small stamps that did not cover the whole surface of the tile. These could be applied in any position, and used several times on one tile or used in combination with other such stamps. The main part of the surface of the tile remained at its original level and the decoration was always at a lower level. The result was less successful when the design was in relief than when it was in counter-relief and the stamp merely made shaped cavities in the surface. Such small stamps had the advantage that they could be used on tiles of any shape or size and were therefore particularly useful for decorating mosaic shapes. Small stamps, one bearing a rosette, another a fleur-de-lis, were used to provide counter-relief decoration on some elements in the mosaic arrangements at Meaux Abbey in Yorkshire. It took longer to decorate tiles in this way and the method was not commercially viable for mass production.

6 Linear decoration

Sometimes, in tiles of one colour, the decorative motifs were applied in outline, not in block as they were in relief and counter-relief decoration. Such linear decoration was occasionally individually cut in the surface of the tile with a stylus or other pointed implement, in which case it is termed 'incised'. Usually, however, it was stamped on the tile and is termed 'line-impressed'. Line-impressed decoration was applied both with small stamps that 33 could be used in a variety of positions and combinations on tiles of any shape or size, and with larger stamps that covered the 34 whole surface of the tile. It seems probable that the small stamps were first used on mosaic shapes and on the square tiles associated with this mosaic, and that the stamps that covered the whole surface of the tile were again a simplification of the

33 Line-impressed designs used on mosaic shapes from Cambridge and Higham Ferrers. Earlier 14th century.

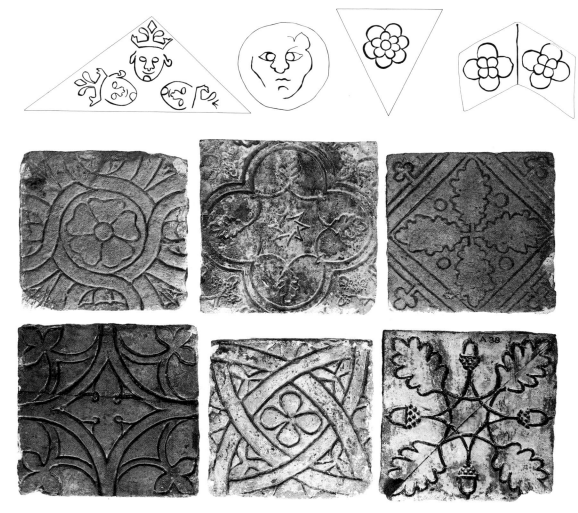

34 Six line-impressed tiles in the British Museum, five decorated with repeating single tile designs, one with a design complete on one tile. This tile was scored to be broken into two triangles; another was decorated with a cracked stamp. 120–133 mm square. 14th century.

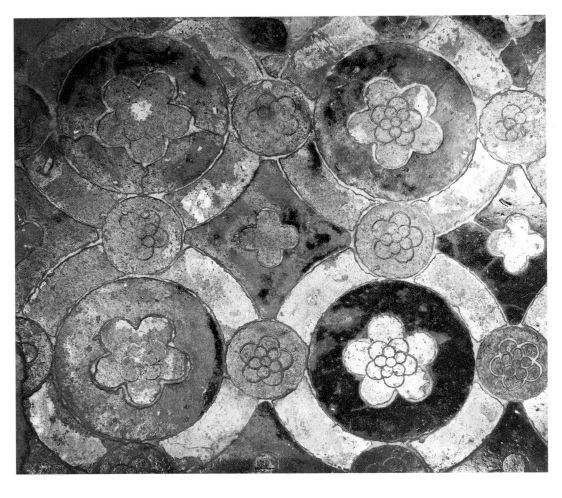

36 *right*. Detail of the pavement of line-impressed mosaic in the sanctuary of Meesden Church, Hertfordshire. *c.* 1315. The same arrangement was used at Ely and Old Warden Abbey.

35 *below*. Line-impressed design showing a man standing between architectural columns. 150 mm square. Earlier 14th century.

process. Line-impressed decoration had been introduced by the beginning of the fourteenth century and continued in use until the middle of the sixteenth.

Line-impressed mosaic was widely used in the first half of the fourteenth century, mainly in areas north of the Thames, and there are a number of places where it can still be seen. A very large area of paving was found *in situ* at Norton Priory, Runcorn, during excavations on the site of the church in the late 1960s. This was lifted and conserved and parts of it are displayed in the site museum. It dates from about 1300. Another large area of paving was found *in situ* in Old Warden Abbey Church in the 1830s, re-examined in 1960, and excavated and lifted in the early 1970s, when the tiles were taken to Bedford Museum where some are displayed. At Ely the body of Prior Crauden's chapel is still paved with its original line-impressed mosaic and more is reset in the south transept of the cathedral. Smaller areas,

most of them reset, can be seen in a number of churches. They are present in the chancel at Icklingham, Suffolk, in the sanctuary at Meesden, Hertfordshire, on the sanctuary steps at Higham Ferrers, Northamptonshire, and in the cathedral at Bangor, Gwynedd. Examples from Pipewell Abbey, Northamptonshire, are displayed in the British Museum.

Fewer shapes were used in this line-impressed mosaic than in the plain tile mosaic. Many of the shapes were rectilinear, stars, hexagons, lozenges and small squares predominating, but arrangements of curvilinear shapes were also used, many based on roundels and the segments of circular bands used to frame them. One such arrangement present in Prior Crauden's chapel was used with slight variations in size and detail at a number of sites, ranging from Norton Priory, Runcorn, to Coggeshall in Essex. A more elongated quatrefoil shape formed part of another curvilinear arrangement known from sites in Shropshire and north Wales.

The glazes were usually yellow and black and the components were laid alternately light and dark as they were in the plain mosaic. Generally the line-impressed decoration was applied to the more elaborate shapes in the arrangements, such as the roundels, stars, quatrefoils and hexagons, and the background shapes that framed them were left plain. In the arrangements from Shropshire and north Wales all the elements were sometimes decorated. The decoration showed up best on the light elements but was not confined to them. The commonest motifs on the small stamps were rosettes, but fleurs-de-lis, birds, and lions' faces were also widely used.

Tiles decorated with the same stamp are sometimes present at a number of places, indicating that one stamp could be used on large quantities of tiles. It seems improbable that the thin upstanding lines on a stamp would last for long if they were made of wood, so experiments were carried out in the British Museum to find out whether metal stamps could be made and used successfully. A small rosette was cut in a clay mould and fired. Molten lead was poured into this mould and left to cool, producing a small lead stamp with a rosette upstanding in thin lines on the surface. This was used to impress decoration on a small clay tile and the result closely resembled the medieval examples. Lead was used because it would have been available in all tileries making glazed wares. The stamp came away from the tile cleanly without the use of a release agent. Such a stamp could be mounted in a wooden block. It would last for a long time and could be passed from one tilery to another. It therefore seems most probable that metal stamps were generally used although the line-impressed mosaic tiles at Norton Priory show the marks of breaks and cracks which indicate that the stamps used there were made of wood.

The same small stamps that were used on the mosaic shapes were used on larger square tiles, and already at Pipewell Abbey stamps that covered the whole of the square tiles were apparently in use at the same time as the small ones. The mosaic element appears to have been dropped by the middle of the fourteenth century and pavements were laid with square tiles only.

One well-defined group of such tiles may have been contemporary with the mosaic shapes. It is not known whether all examples were the product of a single tilery or

37 *right*. Repeating four-tile pattern based on a single line-impressed design (130 mm square approx.) from the tile kiln at Repton, Derbyshire. 14th century.

38 *below right*. Three line-impressed designs used in a series of tiles present in Cheshire, Wales and Ireland. 120–122 mm square. 14th century.

39 *below*. Two line-impressed designs of renaissance heads used on tiles in Normandy and Sussex. 118 mm square. 16th century.

were made at a number of different places. No tilery associated with them has yet been found. They were widespread in Cheshire, north Wales and eastern Ireland. The decorative designs include vine leaves and other quasi-naturalistic foliage. A lion in a pointed quatrefoil frame and a griffin have been found at a number of places including sites in Wales and Ireland. The stamp of the griffin cracked in the manner characteristic of wooden stamps but it was fairly successfully repaired and continued in use, although the crack left a wide upstanding ridge of clay across each tile. The glazes used on tiles in this group were black, brown and yellow or occasionally green.

A piece of paving found *in situ* during excavations at Swords Castle, Co. Dublin, included panels laid with tiles of this type. They were set diagonally to the axis of the room. Each panel included tiles decorated with only one design, but the tiles were set alternately black and yellow providing a chequered effect. One panel was filled with examples of the lion already mentioned. The yellow glaze included patches of brilliant green. Line-impressed decoration did not show up very conspicuously at a distance, although the accumulation of

glaze in the lines tended to give them a darker shade, and added interest was given to the pavements by such alternations of colour.

Another group present in Staffordshire is likely to date from the fifteenth century. The designs are far less refined than any discussed so far and often include elements of relief or counter-relief. They were certainly applied with wooden stamps because not only are the marks of cracks present but on some tiles the marks of the grain of the stamp are visible in the bottom of the cavities. This suggests that a soft wood was used for the stamps; that might break rather easily, which would account for the presence of so many different versions of the designs.

The latest group of line-impressed tiles 39 known dates from the sixteenth century. Most of the tiles have been found in Sussex and only two designs are present, both representations of male heads in renaissance helmets. Tiles decorated with these stamps were manufactured at Château-neuf-en-Bray in Normandy, and it is probable that the examples found in England were imported.

40 Detail of a panel of line-impressed tiles in a pavement found during excavation at Swords Castle, Co. Dublin, in 1971. The designs are identical with those found in Cheshire and Shropshire. 14th century.

7 Two-colour tiles

Most popular and widespread of all the types of decorated medieval tiles were those on which the surface decoration was applied in clay of a contrasting colour to that of the body of the tile. In the vast majority the body clay was red and the decoration was applied in white clay, but very occasionally when the body of the tile was buff, the decoration was applied in a specially prepared red clay. Two-colour tiles were usually glazed with the clearest lead glaze available that resulted in a brown and yellow tile. On the rare examples that were glazed with the lead-copper glaze to produce green there is very little contrast between the red and white areas of the surface and the decoration is obscured. The brown and yellow tiles were those most frequently reproduced during the nineteenth century and are the most familiar today.

It is not known when or where two-colour decoration was first used. It may have been developed in both France and England in the second quarter of the thirteenth century, perhaps accidentally, perhaps as an experiment. In all but a few rare groups the white clay was inserted in cavities stamped in the surface of the tiles. One group in East Anglia and another in Wiltshire were decorated with designs stencilled or painted on top of the surface in thick white slip, and another group, so far unique, from Shaftesbury Abbey, had the decoration piped on to the surface through a nozzle. Various methods of inserting the white clay into the stamped cavities were employed, but in every case the clarity of the decoration depended upon the careful trimming and cleaning of the surface after the white clay had been applied.

In all the earliest known tiles the decoration was inlaid. Cavities 1-2 mm deep, or sometimes even deeper, were stamped in the surface of the tiles, and white clay in a fairly solid plastic state was pressed into them. Surplus clay was cut off the top, and the outline of the decoration was trimmed with a knife. A wooden bat was then placed on the surface and struck with a mallet. This served to consolidate the inlaid white clay and to break down all the surface clay into smaller particles to produce a smoother top. Decoration applied by this method was clear and wore well but presented technical difficulties because the red and white clays had different rates of shrinkage during both the drying and the firing processes. When the white clay shrank more than the red, cracks appeared between the inlay and the body and if these became very deep the inlay fell out. A small amount of body clay was sometimes mixed with the white clay in an attempt to equalise the rate of shrinkage.

Later, in the fifteenth and sixteenth centuries, the clay seems usually to have been introduced into the stamped cavities as a liquid slip. This adhered to the sides and base of the cavities, and sometimes lipped the edges. When it shrank it still clung to them, but the surface of the white areas became concave. In more recent times the liquid slip was trailed into the cavities through a cow's horn, perforated at the tip, and it is reasonable to suppose that this method was already in use in the later medieval period. In some series of tiles decorated in this way the stamped cavities were very shallow; in others they were deeper and the white slip formed a thin layer in the bottom of the cavities only,

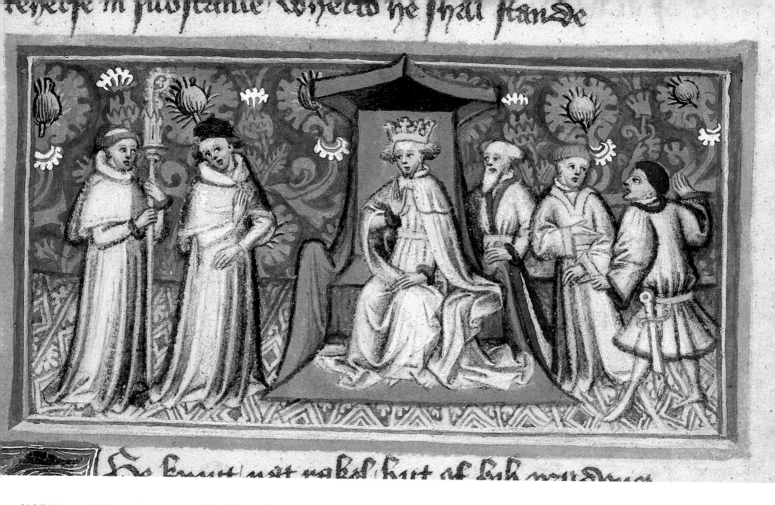

Fo knowst most raboll hert of Rih wordyng

41 Miniature painting showing St Edmund consulting a bishop, on a pavement of two-colour tiles, from Lydgate's *Life of Saint Edmund in English Verse*, British Library MS Harleian 2278 f. 54.

and as its surface was below the level of the top of the tile it was thus protected from wear. Sometimes this layer of slip was so thin that marks of the wood grain of the stamp can be seen through it.

Other processes intermediate between the deep plastic inlay and the poured liquid slip were also employed but it is difficult to determine exactly what they were. Before the end of the thirteenth century a much shallower inlay was being used, and greater shrinkage mattered less in the smaller volume of white clay. In the

late thirteenth century and the fourteenth century other techniques were developed and various suggestions have been made about the possible processes used. These include the printing of the decoration into the surface with a stamp covered in white slip, the covering of the whole tile surface with white slip and stamping through it, or the filling of pre-stamped cavities with a very thick white slip. Any or all of these methods could have been used, but it seems probable that only the last would have been completely successful because

42 Designs depicting the heads of a king and a lady on inlaid tiles from the site of Chertsey Abbey, Surrey. 49 mm diam. *c.* 1250.

during the other processes the wooden stamp would have become clogged with white clay. The smudged appearance of the decoration of many of these tiles is likely to be due, not to the method of applying the white clay, but to the inadequate cutting and cleaning of the surface afterwards.

The two-colour tiles from the site of Chertsey Abbey have become better known than any other English medieval tiles, and justly so because of their technical and artistic excellence. They are now known to form part of a fairly widespread group, but far more examples have been recovered from Chertsey than from any other site. Unfortunately, not one has been found *in situ* and many are fragmentary. The first examples to be published, as long ago as 1787, were two circular tiles 49 mm (2 in) in diameter decorated one with the head of a bearded king, the other with the head of a lady. Both tiles are in the British Museum. This publication alerted people to the fact that high-quality medieval tiles might be found at Chertsey and a further discovery was made in about 1820. The tiles then recovered included decorated mosaic shapes and pieces of large circular tiles portraying human figures. The next major discovery of tiles was made by workmen in 1853. These came to the notice of Dr Manwaring Shurlock who had already had some experience of medieval tiles in Oxford. He obtained permission from the owner of the ground to take what he wanted from the workmen's dump and set about piecing them together and working out the designs, and it is to him that we owe most of our information.

In 1858 Henry Shaw published illustrations of sixteen pictorial roundels from 230 to 255 mm (9-10 in) in diameter as well as other circular, mosaic and rectangular de-

signs from Chertsey tiles all drawn by Manwaring Shurlock. An excavation carried out in 1861 by Surrey Archaeological Society produced more tiles but nothing *in situ*, and in 1885 Shurlock himself published the results of his researches in a folio volume containing thirty-eight pictorial designs reproduced at actual size, most of them identified as illustrations of the romance of Tristram and Isolde. Shurlock suggested that the pictures that did not

43 Inlaid roundels from the site of Chertsey Abbey, Surrey, decorated with scenes illustrating the Romance of Tristram and Isolde. Restored and assembled in the British Museum. *c.* 1260 – 80.

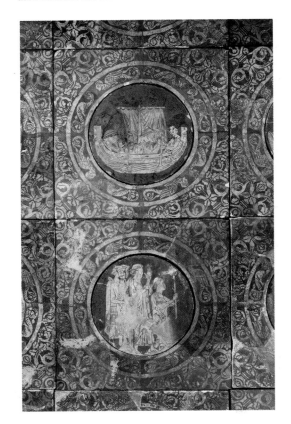

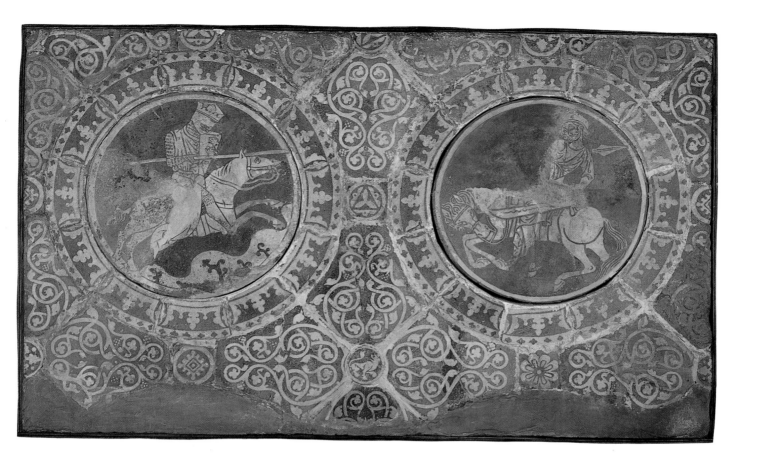

44 Panel of inlaid mosaic tiles (800 × 500 mm) displayed in the British Museum, assembled from tiles found on the site of Chertsey Abbey, Surrey, showing the combat between Richard I and Saladin. *c.* 1250.

44 belong to the Tristram series probably illustrated a romance of Richard Coeur de Lion. Only two in fact belong to that story. The rest of the pictures illustrate combats, some between a man and a lion.

The combat pictures were fired in four sections making a roundel about 250 mm (10 in) in diameter and were used as part of an elaborate mosaic assembly. Only one arrangement of shapes was used, but each shape is known to have been decorated with a number of different designs and there is no information about the way in which these were originally assembled.

Some of the segmental tiles that form the circular band round the pictorial roundels bore Latin inscriptions, among them RICARDUS REX, King Richard.

The Tristram pictures were fired in one piece on a roundel about 230 mm (9 in) in diameter and were set in a 405 mm (16 in) square frame, fired in four parts and decorated with a circular band and foliate corners. This shape and the foliage are present in only one form but the circular bands are decorated with various different motifs and combinations of motifs, and also with Norman-French inscriptions

45 *left*. Four-tile panel (800 × 220 mm) depicting an archbishop, reassembled from pieces from the site of Chertsey Abbey. Waste tiles belonging to this series were found associated with the kiln excavated at Chertsey in 1922. 1290s.

46 *right*. Design in the Tristram series from Chertsey Abbey showing the porter opening the gate of the castle: (*top*) as used on the roundels for which it was designed (232 mm diam.). *c.*1260-80; (*bottom*) as reused with minor additions and flanked by architectural borders on square tiles (228 mm square) associated with the kiln at Chertsey. 1290s

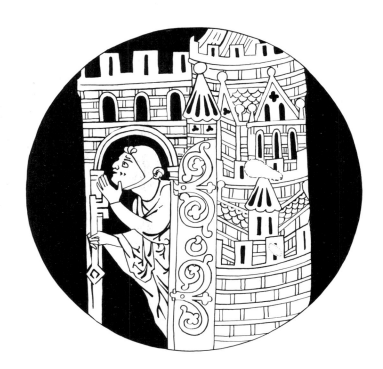

47 Two inlaid tiles from Chertsey Abbey: (*left*) a mosaic roundel (120 mm diam.) decorated with one of the Labours of the Months, weeding, designed for a mosaic arrangement: (*right*) the Leo in the companion zodiac series reused within a circle on a tile 135 mm square. Probably 1250s and 1290s.

among which the name TRISTRAM occurs. This method of framing the circular pictures was simpler to fire and to lay than the mosaic associated with the combat series.

In 1922 the substructure of a tile kiln was found in a garden in Chertsey and excavated. Associated with this kiln were waste tiles, most of them from a series of panels 45 depicting a king, a queen, an archbishop and a crucifixion. There were also frame tiles of the type used with the circular Tristram pictures, and square tiles on which Tristram pictures were also used 46 flanked by architectural borders. These last were probably intended for use with the panel tiles which also have architectural borders. Such square tiles would have been even easier to fire and lay than the circular shapes and frame tiles.

47 Many other square tiles and some 48 oblong border tiles were being used at Chertsey at the same time as the mosaic and pictorial tiles. The decoration was inlaid and the quality of both design and manufacture was very high. Sprays and

scrolls of stiff-leaved foliage and fleurs-de-lis form the basic motifs of many of the designs which range from those complete on one tile, through repeating patterns and four- and nine-tile combinations, to great repeating sixteen-tile patterns.

No exact date is associated with any of the tiles from Chertsey but it seems probable that the combat series and related mosaics were first made in the 1250s, and the Tristram series and their frame tiles somewhat later. It is reasonably certain, because of their association with a datable series at Halesowen Abbey, West Midlands, that the panel tiles and the square versions of the Tristram pictures were made in the 1290s.

Closely associated with these thirteenth-century inlaid tiles from Chertsey Abbey is the pavement still *in situ* in the chapter 49 house of Westminster Abbey. This is known to have been completed by 1258/9 when Henry III ordered that the surplus tiles remaining from the chapter house pavement should be used in the paving of St

48 *right*. Design spread over two border tiles (each 110 × 67 mm) used at Chertsey Abbey. 13th/14th century.

49 *below*. Detail of a panel of inlaid tiles (160 mm square approx.) in Westminster chapter house, decorated with a repeating four-tile design including the cock and fox of Aesop's fable. 1250s.

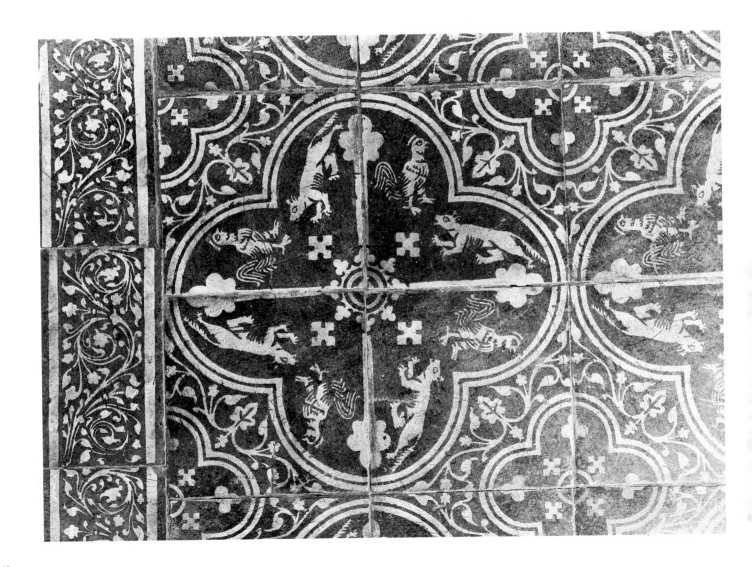

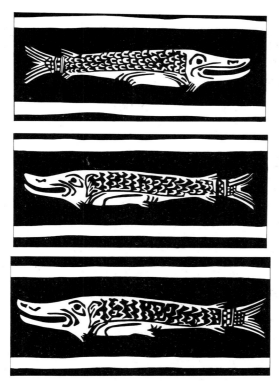

50 *right*. Fish border designs in Westminster chapter house (210 × 95 mm approx.): (*top, middle*) 1250s; (*bottom*) 1860s.

51 *below*. Reproductions of designs in the intrusive panels in the pavement of Westminster chapter house facing the riser of a step in Powerstock Church, Dorset.

Dunstan's chapel in Westminster Abbey. The arrangement of the chapter house pavement in panels running from east to west has already been described. Each panel was laid with tiles of the same design and the panels were separated by decorated oblong border tiles. In two panels in 50 the south part of the floor the scheme is broken by the inclusion of horizontal bands of pictorial tiles and inscriptions. Perhaps those were surplus from another pavement recently laid and Henry III ordered that they were to be used up in the chapter house. If this were indeed so, the pavement for which they had been made would have been spectacular and one can only regret its loss. The designs include seated figures of a king, queen and abbot, 51 two minstrels, St Edward giving his ring to a beggar, and a hunting scene. The quality 52 is so high that one feels that they must have been designed by one of the king's painters for use in Westminster Palace, where a tiler is known to have been

52 *above*. Designs of a three-tile hunting scene in the intrusive panels in Westminster chapter house. Each tile 190–195 mm square. 1250s.

53 *right*. Two designs from a three-tile hunting scene on pieces of inlaid tiles recovered from the foundation of Bourne Hall, Ewell, Surrey, when it was demolished in the 1960s. 150 mm square approx. Later 13th century.

working at this period and orders for tile pavements are recorded.

The most outstanding of the designs in the chapter house, apart from these intrusive elements, is a large shield of the royal arms with supporters, spread over four tiles. Two panels laid with this design flank the central area of the building and emphasise its royal status. The lions may have been drawn by the artist who drew the zodiac Leo at Chertsey, but the Westminster lions, unlike the Chertsey Leo, have

their ribs depicted. A small motif present at Westminster is a quatrefoil composed of five contiguous squares. This is characteristic of the chapter house designs and of others derived from or influenced by them, and is unknown in the designs of any other series.

It was once thought that the Chertsey and Westminster tiles were unique, but it is now known that they were part of both a local and a more widespread group of pavements. The circular pictures from

54 Inlaid tiles (160 mm square approx.) decorated with a four-tile design of the royal arms in Westminster chapter house: (*left*) original tiles of the 1250s; (*right*) replicas of the 1860s.

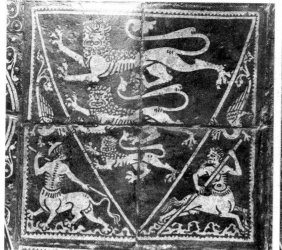
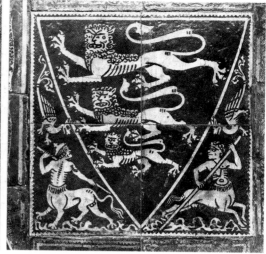

55 Westminster design with the cock and fox (see no. 49) and three others with the same theme, all probably later 13th century.

56 Three border designs with castles and fleurs-de-lis, perhaps associated with Eleanor of Castile: (*from left to right*) from Chertsey Abbey; from Hailes and Halesowen Abbeys; from Kenilworth Abbey and Maxstoke Priory, both in Warwickshire. 162 – 172 × 60 – 75 mm. c.1290 – 1310.

Chertsey were used at Winchester, and at Halesowen Abbey, where they were combined with frame tiles decorated with foliate scrolls similar to those at Chertsey, but with vine leaf terminals. At Hailes Abbey in Gloucestershire frame tiles very like those at Chertsey were used with circular tiles of the same size with different pictorial and foliate decoration. A design based on castles and fleurs-de-lis on oblong border tiles, present at Chertsey, is known in variant forms from Hailes, Halesowen and Kenilworth Abbeys, Maxstoke Priory and Chester Cathedral, and there were derivatives in other places.

This border design was probably first used in the 1290s with the Chertsey panel tiles of the king, queen, archbishop and crucifixion. The archbishop from this series was used at Winchester and other sites in Hampshire. Non-pictorial designs

from both Westminster and Chertsey have been found on the sites of Waverley Abbey, Merton Priory and Newark Priory all in Surrey, at Titchfield Abbey in Hampshire, and Cuxton in Kent, and there were many close derivatives at other places in Surrey, [53] Hampshire, West Sussex and Kent, and [57] their influence spread into Essex. Westminster chapter house and the site of Chertsey Abbey remain the places from which the greatest numbers of these tiles are known, but the presence of scattered examples from so many different sites indicates that comparable pavements were laid in many other important buildings up and down the country in the second half of the thirteenth century.

Although the use of inlaid mosaic and pictorial designs was more widespread than was once apparent, the more elaborate shapes and decorative designs gradually gave way to the manufacture of square tiles with simpler decoration. Lozenge-shaped tiles remained popular during the first part of the fourteenth century but even they seem rarely to have been made later.

Accidents of survival and discovery make it difficult to present a comprehensive picture of the spread of two-colour tiles. Winchester undoubtedly had inlaid mosaic of the Chertsey combat series, and at least the archbishop from the later Chertsey panels. A very beautiful bird on a tile from [58] Winchester Castle is also present on a tile from Halesowen where the association [59] with Chertsey inlaid mosaic has already been mentioned. Winchester Cathedral [12] still retains a great part of the medieval paving of the retro-choir. This may date from the period of the building in the 1230s or may be a few decades later. The designs are simple and bold and are carried out in deep inlay. They form part of, and may well

57 *right.* Two designs including the Westminster five-square quatrefoil: (*top*) from Newark Priory, Surrey; (*bottom*) from Lesnes Abbey, formerly in Kent. 145 and 100 mm square, later 13th century.

58 *below right.* Design with a bird used on tiles found at Winchester Castle and Halesowen Abbey. 125 mm square. Later 13th century.

59 *far right.* Paving of inlaid tiles found *in situ* in the chancel of Halesowen Abbey church, now displayed in the British Museum. It includes the design in no. 58. Later 13th century.

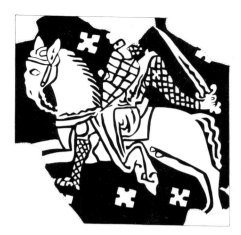

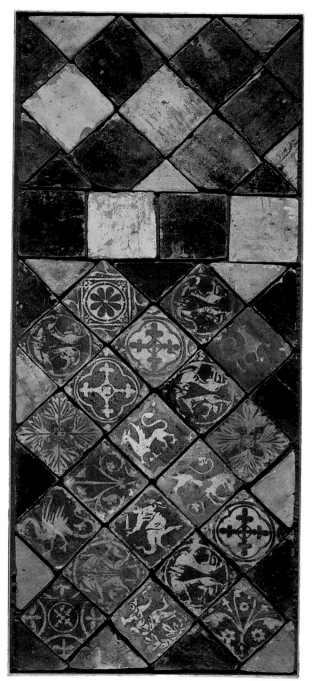

60 Two pairs of lions and griffins from Clarendon Palace: (*top*) associated with the kiln; (*bottom*) associated with the pavement from the Queen's chamber. 160 and 135 mm square approx. 1240–4 and 1250–2.

61 *opposite*. Segment of a circular pattern from the first floor chapel, Clarendon Palace, built for Henry III by Elias of Dyrham, assembled in the British Museum from tiles recovered during excavation and plaster casts. 1240–4. See also pp. 2–3.

be at the beginning of, a series of square inlaid tiles widely used in Hampshire and the nearer parts of Sussex. Near the entrance to the lady chapel are a number of tiles decorated with lions and griffins in circles that may be later than the rest of the pavement. These lions and griffins formed two of the most popular motifs in the later thirteenth century and continued into the fourteenth. They are known in many variant forms from sites as far away as north Wales, Lincolnshire and Devon as well as over the whole of Wessex. In 1892 B. W. Greenfield illustrated seven variant forms of the lion and seven of the griffin from Hampshire alone. Examples are present in Winchester College which was not founded until 1387 and it was therefore thought that this series remained in production until early in the fifteenth century. It is now clear from both documentary and archaeological evidence that these tiles were salvaged and reused when the neighbouring St Elizabeth's College was demolished in 1545.

Tiles belonging to the same series as those in the cathedral were found on domestic sites in the city during the excavations of the 1960s. By the end of the first quarter of the fourteenth century many buildings in Winchester, both lay and ecclesiastical, must have been bright with these gleaming new decorated pavements.

Probably at about the same time as the earliest tiles of the Chertsey-Westminster and the Winchester groups were being made, another series was being made in south Hampshire and Wiltshire. The most striking elements here, as at Chertsey, were inlaid tile mosaics, but if they ever included pictorial elements no examples are known to have survived. At Beaulieu Abbey and Clarendon Palace large circular arrangements were composed of concentric bands of tiles. One at Clarendon Palace had been in the king's private chapel on the upper floor of a two-storey block built for Henry III by Elias of Dyrham in the 1230s. Scattered tiles from this long-collapsed pavement were found among the ruins of the building during the excavation of the site in the 1930s. A reconstructed segment of the circle has been assembled using the tiles then recovered and some plaster replicas, and is displayed in the British Museum. It is composed of alternating bands of narrow green glazed tiles and wider brown and yellow inlaid tiles. The outermost deco-

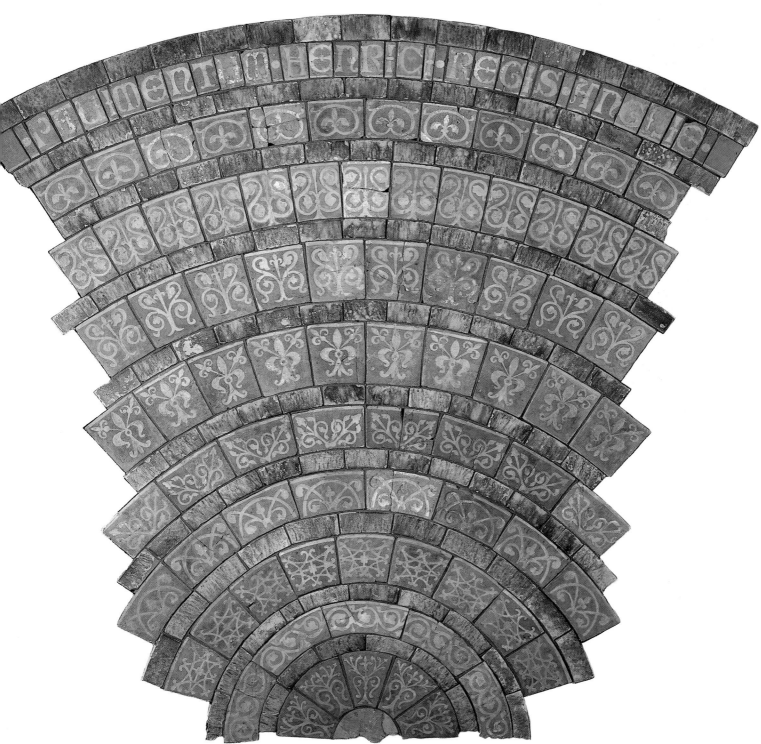

rated band contains an inscription but as it is not known what this was the letters have been used to compose a label for the pavement. This circular inlaid mosaic can be dated with reasonable certainty to the years between 1240 and 1244. Other segmental tiles recovered from the site indicate the presence there of at least one and probably two more inlaid circular arrangements of concentric bands. In one of them some at least of the narrow bands were also composed of inlaid decorated tiles.

Scattered tiles recovered from the site of Beaulieu Abbey indicate that at least one comparable circular arrangement was used there, possibly earlier than any of the examples at Clarendon Palace, and other inlaid mosaic shapes and letters from inscriptions were also found there. Two such circular arrangements were found in the cloister at Muchelney Abbey, Somerset, in the 1880s and relaid in the adjoining **63** parish church. Both arrangements are much smaller in diameter than that from the king's chapel at Clarendon and are likely to be later in date. Some of the

narrow bands at Muchelney have inlaid decoration and some are composed of plain black glazed tiles. Isolated fragments indicate that Glastonbury also once had such a pavement.

It is fortunate that tiles belonging to the circular arrangement at Clarendon were found in association with the remains of a kiln there in 1937 where many other waste tiles were also recovered. The kiln, of which **5** only the furnace, stoke pit and part of the back wall of the oven survived, was lifted in 1964 and later conserved and displayed in the British Museum medieval tile room. **62** The tiles associated with this kiln were mainly large square tiles with bold deeply inlaid decoration, but a few oblong border tiles and tiles designed to be set vertically **64** on the risers of steps were also recovered. A fine lion was present on one of these waste **60** tiles. He is represented as a solid block without any of the internal detail present in the Chertsey Leo or the Westminster lions; this simpler type of block designing is characteristic of most decoration on medieval tiles. It was not only easier to

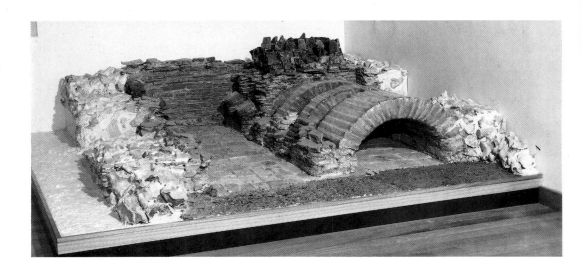

62 Remains of the tile kiln from Clarendon Palace, conserved and displayed in the British Museum. 1240–4.

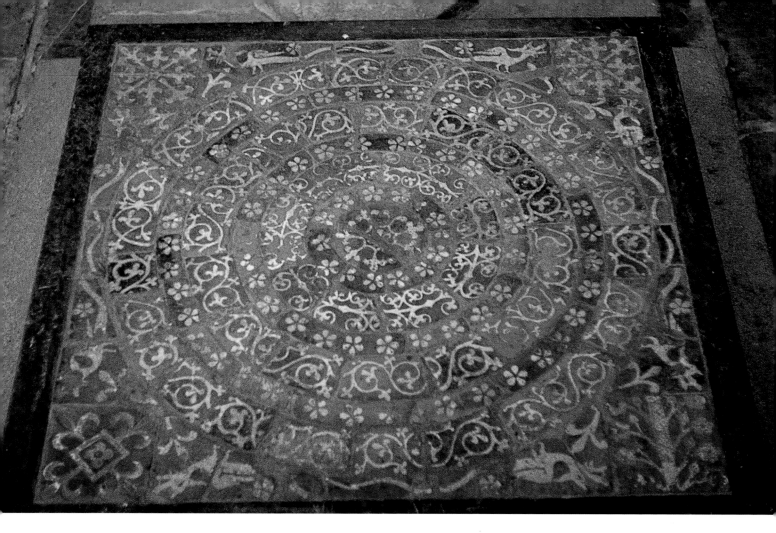

63 Panel of inlaid tile mosaic found on the site of the cloisters of Muchelney Abbey, Somerset, in the 1880s and reset by the font in the parish church. Mid-13th century.

reproduce but, being bolder, it also made a more immediate impact when seen on the floor. Tiles decorated with some of the same stamps were found among wasters recovered during the excavation of a kiln site at Nash Hill, Lacock, in 1971 demonstrating again that the same decorative stamps were used in different places. The Nash Hill kiln is thought not to have begun operation until several decades later than the kiln at Clarendon, possibly not much before the end of the thirteenth century.

Among the waste tiles at Nash Hill were examples of a series of large well-designed tiles decorated with heraldic shields. Early versions of these designs are present in the pavement of the old refectory at Cleeve Abbey in Somerset, associated with Henry III's brother Richard of Cornwall and his son Edmund. Three different shields are represented on the large tiles used in the south end of the building where the top table would have been placed. These bear the arms of England, the arms of Richard as

65

64 *right* Knights in combat designed to face the risers of steps: (*top left*) from Great Bedwyn, Wiltshire; (*top right*, *bottom*) from the Carmelite monastery in Bristol. 205—222 × 135—162 mm. 13th/14th century.

65 *below*. Inlaid tile pavement in the old refectory, Cleeve Abbey, Somerset. *c*.1271/2.

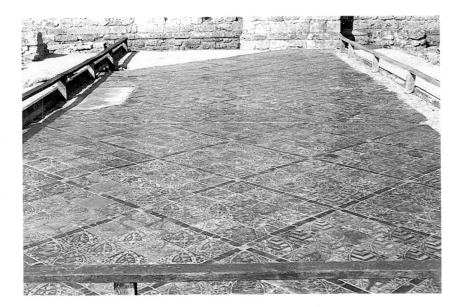

Count of Poitou and the arms of Clare, supposedly celebrating the marriage of Margaret de Clare to Edmund in 1271/2. This suggests the earliest date for the design of this series. Many derived versions were made and other shields of arms were added, both in the large size and in smaller versions.

The rest of the floor of the old refectory was paved with smaller square tiles, some decorated with other heraldic designs associated with Richard of Cornwall, including the double-headed eagle displayed of the King of the Romans. These designs and their derivatives were widely used in Somerset and the adjoining parts of Wilt-66 shire, and in variant forms spread as far as Cornwall. They were made at a number of

different places but in all the known examples the white clay was inlaid.

Probably at about the same time that the great circular arrangements of concentric bands were being laid in the south, other comparable examples were laid at Jervaulx Abbey in Yorkshire. These were found in the pavement of the abbey church in 1807 and recorded. Another circular inlaid pavement was found during excavations on the site of Kirkstall Abbey in 1955. Fewer narrow bands, either plain or decorated, were included in these Yorkshire examples than in those in the south, and foliate sprays radiate out over several bands of tiles. No exact date is known for the Yorkshire series but the foliate scrolls and stiff-leaf terminals suggest the middle decades of the thirteenth century.

A very fine series of well-designed square

inlaid tiles was used at Byland and Rievaulx Abbeys, certainly later than the plain mosaic because at Rievaulx tiles of this type replace the mosaic where it was disturbed after alterations to the east chapel in the north nave aisle. Most tiles in this series have simple bold designs carried out in deep inlay. The body fabric is reduced pale grey and the glazed tiles are light olive green and pale yellow. The designs are different from those on square tiles associated with the inlaid mosaic at Jervaulx where heraldic shields are the commonest motif.

Heraldic shields also decorate the majority of the inlaid tiles which pave the eastern arm of the abbey church at Hailes in Gloucestershire, extended in the 1270s to accommodate a shrine for a phial of the Holy Blood presented to the abbey by Edmund of Cornwall in 1271. Part of this pavement was uncovered during excavations in 1968. All the heraldry is associated with Richard of Cornwall, his three wives, and the families whose lands Edmund had acquired. The tiles are smaller and thinner than most of those discussed so far and have a distinctive appearance. The body is sandy and hard-fired to a rather deep red or a bluish grey where it is reduced. The backs were stabbed with an irregular scatter of small holes made with an implement resembling the pointed end of a round pencil. The clay used for the white inlay is unusually fine and hard. It has lasted better than the body fabric and on worn examples it stands up above the surface of the tile body.

In the area of paving exposed in 1968 in the north presbytery aisle and north-west part of the chevet, each panel was filled with tiles of one design, but oxidised and reduced examples were laid alternately to give an all-over effect of olive green and

66 Heraldic designs present in Wells Cathedral, each a smaller version (135 mm square approx.) of those in the old refectory, Cleeve Abbey: (*top*) England; (*left*) Poitou; (*right*) Clare. Last quarter of 13th century.

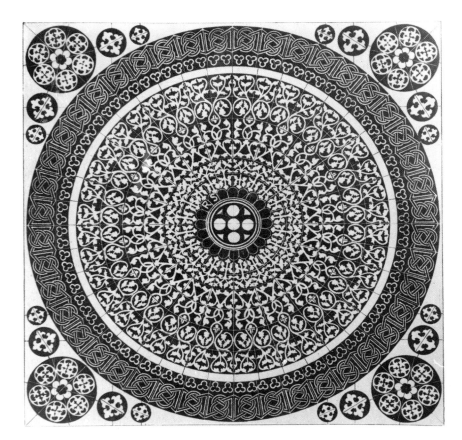

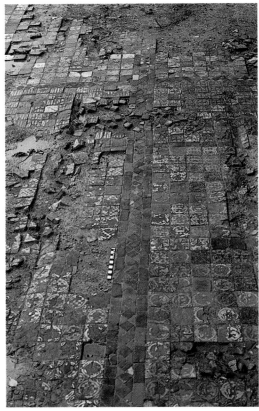

67 *above*. Drawing of an inlaid mosaic based on circular bands found on the site of Jervaulx Abbey, Yorkshire, published by Henry Shaw in 1858. 13th century.

68 *above right*. Part of the pavement of inlaid tiles in the north presbytery aisle at Hailes Abbey, Gloucestershire, during excavation in 1967. 1270s.

brown checks. This indicates that the tilers were controlling the atmosphere in the oven of their kiln to produce oxidised tiles at one firing and reduced tiles at another. Although the arms of England and Poitou, and the eagle displayed, are present at both Cleeve and Hailes, the actual designs used at each are entirely different and one may suppose that a different band of tilers was employed at Hailes. No kiln associated with the tiles has been found.

A series of tiles that was widely distributed from Gloucestershire through Oxfordshire to Warwickshire, Leicestershire and south Northamptonshire has the same distinctive appearance as these tiles from Hailes but so far only one design identical with any known from Hailes has been found elsewhere. This is an example of the design of the arms of England, found at Catesby Abbey in Northamptonshire, made after the wooden stamp had become worn and damaged. The rest of the designs seem to be derived from or to resemble those used in Wessex, and because of this and the stabbed holes in the base the series has been called 'stabbed Wessex'. If those recovered during excavations in St Peter in

the East in Oxford date from the 1330s as seems probable, the series was in production at least intermittently for about sixty years. No kiln associated with these tiles has yet been found, but the fabric of all the tiles both from Hailes and from the widely distributed 'stabbed Wessex' series is so similar that it is thought that all were made at one tilery working on a commercial basis after the special commission for Hailes had been fulfilled.

The fourteenth century saw a major expansion in the commercial production of two-colour tiles and there can have been few places in lowland England that were not within reach of a tilery. During this period most parish churches and many manor houses and merchants' houses were furnished with tile pavements. The best documented tilery is that at Penn in Buckinghamshire because between the 1330s and the 1380s its products were being used by the king's clerks of works in royal buildings, and records of some of

69 Inlaid heraldic tiles (135 mm square approx.) from the eastern arm of the abbey church at Hailes, Gloucestershire, displayed in the British Museum. 1270s.

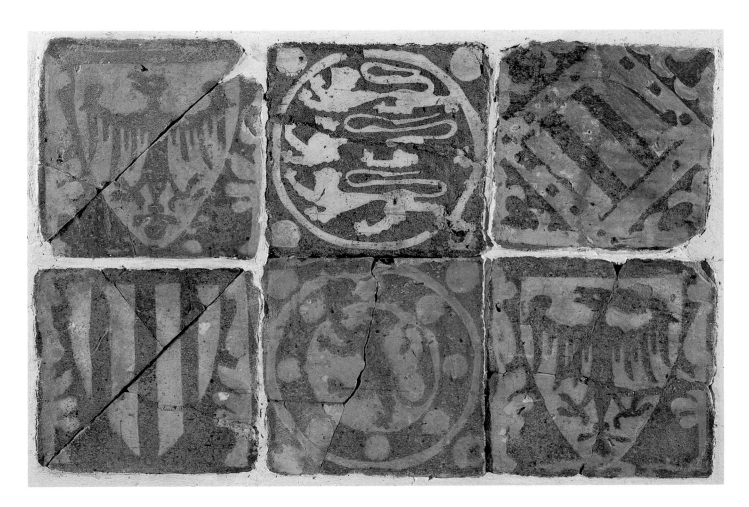

70 Three designs used at the tilery at Penn, Buckinghamshire, representing three phases of production. 118, 110 and 106 mm square. 1330s–80s.

their transactions survive. The tiles were selling for about six shillings a thousand at the kiln and customers had to pay separately for transport. We know from royal records that some at least of these commercially produced tiles were laid by experts, and it seems probable that these were attached to the tileries and could be hired or their services booked when the tiles were purchased. Some support for this is available for Penn where as well as two tilers a paviour was listed among the taxable inhabitants in 1332.

Besides being used in most of the churches in Buckinghamshire and many in south Bedfordshire and other neighbouring counties, Penn tiles were distributed to sites along the Thames from Oxford to London and up the Wey as far as Guildford, and were even used in such places as Chertsey Abbey which had been making its own tiles only a few decades earlier. It seems probable that the change to the use of cheaper mass-produced tiles was accelerated by the Black Death which reduced the purchasing power of the wealthy through loss of rents and increased labour costs.

70 There seem to have been three successive qualities of tile produced at Penn. The earliest are the largest, the best fired and

have the most interesting designs including human figures, animals, inscriptions and some heraldry. They probably antedate the Black Death. Tiles of the next series are slightly smaller and less well made, the decoration includes large numbers of repeating patterns based on one tile or groups of four identical tiles, and it is this series that seems to account for the 71 bulk of the production of the tilery. The tiles of the latest group are smaller still, tend to be dished and overfired with the resulting purplish brown and orange colour, and the white decoration is often smudged. They seem to date from the 1380s. The three qualities may represent three generations of tilers, the last of whom had lost the technical expertise of their predecessors.

It was in relation to these Penn tiles that Loyd Haberly in the 1930s suggested the technique of 'printing' the decoration with a stamp 'inked' with white slip. The term 'printed' was used to describe these and many other series of two-colour tiles on which the decoration was not inlaid. It is now thought that this technique would not have been possible with medieval materials, but it is difficult to determine what method was actually used. Possibly in the earliest group the white clay was intro-

duced in a viscous state and the surface of the tile was carefully trimmed and cleaned; in the main phase the white clay was introduced as a very thick slip and less care was taken over the finishing, and in the last phase a more liquid slip was used.

At Penn the decorated floor tile industry was added to an existing roof tile industry that probably continued long after the production of floor tiles had been abandoned. This was the first commercial floor tile industry to be studied in detail and was once thought to be the first to be established. It is now known that the 'stabbed Wessex' industry and some of those in Wessex itself were earlier and that there were also earlier industries in Essex and Hertfordshire from which that at Penn may have been derived. Recent work in the City of London suggests that commercially produced tiles were already available there by about 1260.

At least three tileries making two-colour floor tiles were working in Essex in the last decades of the thirteenth century and the early part of the fourteenth. Kilns associated with two of them have been found, one at Stebbing, the other at Danbury near Chelmsford. The latter was found in the 1930s and the site was excavated in 1974. [6] Two kilns, one the most complete ever recovered, two workshop areas and a possible heated drying shed, two ovens for the preparation of glaze, a probable dwelling, perimeter ditches and numerous pits were found. Some of the decorative designs on waste tiles from the site and on other products of this tilery recognised elsewhere were undoubtedly derived from those of the Westminster-Surrey group. They include a hunting scene, stiff-leaf foliate scrolls and sprays and human figures on segmental tiles. Other grotesque figures are in a later, fourteenth-century, style and many simpler designs were also present. Some of them were also used on

71 Paving of Penn tiles found *in situ* during excavations in the church of Elstow Abbey in 1968. Mid-14th century.

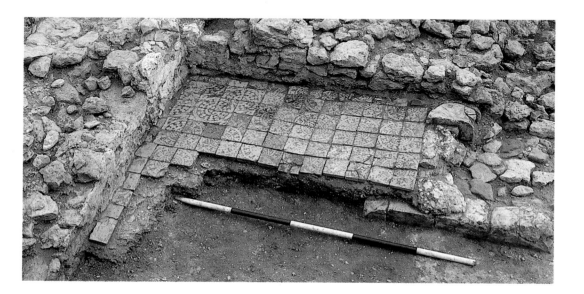

74 *right*. Part of a pavement found *in situ* during excavations on the site of Seal House, just upstream from London Bridge, in 1974. It was the first tile paving found *in situ* on a domestic site in the City of London. *c*.1260–1300.

72 *below*. Four tiles (125 mm square approx.) of the Hertfordshire series from St Albans, Hertfordshire. Early 14th century.

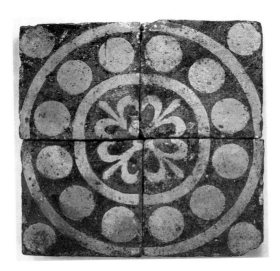

73 *below*. Three tiles of the Westminster Muniment Room type in the British Museum, two decorated with a design present in the paving found at Seal House, London. 105–108 mm square. Probably later 13th century.

tiles of a group first recognised in Hertfordshire but now known to have a wider distribution in East Anglia. It is not known where this Hertfordshire series was made. Some of the designs used on these Hertfordshire tiles and at Danbury also appear on Penn tiles. It could well be that a tiler associated with the Danbury or Hertfordshire industries migrated to Penn and established the highly successful industry there.

A series of tiles that have been called 'Westminster' because they were first recognised in the pavement of the muniment room at Westminster Abbey, where they still remain, has been the subject of varied opinions but can now be dated with certainty to the latter part of the thirteenth century in the London area because examples have been found associated with a datable phase of the Thames-side quays. Tiles of this type are also present in Westminster Abbey in the chapel of St Faith. It is not known where they were made although the London area is a possibility. They were distributed apparently along Watling Street from Canterbury to Warwickshire. They are probably

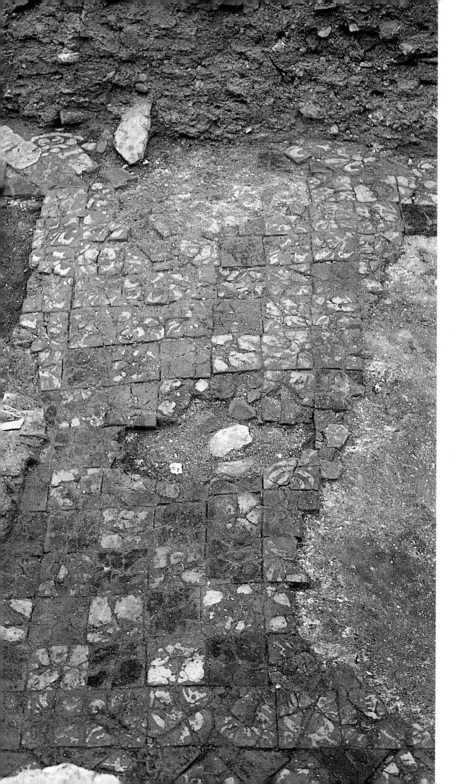

the worst-made medieval tiles ever to be commercially successful, although even worse examples were produced, probably experimentally for purely local use, in many places. The designs include a mounted knight, a bird, a shield of arms, a 73 foliate cross and various fleurs-de-lis. The tiles are quite thick and the stamped cavities are deep but the surface treatment was inadequate. It looks as if the white clay was inserted as a very thick slip but that instead of cutting off the surplus white and body clays from the top of the tile the tiler merely wiped off the surplus white clay, covered the top with a bat and hammered it down, with the result that the surplus body clay rose up a little during firing. The surface of the tiles is rarely flat, and on the same tile some of the decoration may be smudged because the white clay has overflowed the cavities and some of the cavities may not be adequately filled, leaving hollows in the surface. The first piece of decorated tile pavement to be found on a domestic site in the City of London was laid with these tiles. It was in a house just 74 upstream from London Bridge, discovered during excavations on the site of Seal House in 1974.

The use of Chertsey-type tiles at Halesowen Abbey and of Hailes-type tiles at Kenilworth doubtless provided the initial impetus for the establishment of a commercial industry in Warwickshire. The remains of one kiln were found at Stoke, Coventry, in 1911, and there were doubtless others because the tilers of Coventry were sufficiently important to be allowed to form a guild, a very rare privilege.

Another Warwickshire industry was situated at Chilvers Coton, Nuneaton, where rescue excavations in 1967 recovered the site of an extensive pottery with numerous

75 Panel of tiles (120 mm square approx.) from the site of Ulverscroft Priory, Leicestershire, made at Chilvers Coton tilery in Warwickshire, assembled and displayed in the British Museum. Second quarter of the 14th century.

kilns, two of which were tile kilns. The earlier was dated in the archaeological sequence to the late thirteenth century. The tiles associated with it were already known from Halesowen Abbey and from Lilleshall Abbey in Shropshire. The tiles are small with simple designs carried out in deep inlay. They provide an obvious link between Halesowen and Chilvers Coton, but it seems most probable that the Halesowen and Lilleshall examples were made at different places, neither perhaps at Chilvers Coton. The second tile kiln found there was later. A very distinctive group of tiles was associated with it, previously known mainly from the site of Ulverscroft 75 Priory in Leicestershire. These tiles are very well made, pinkish red in colour with decoration neatly applied in shallow inlay. Examples that retain their glaze are a golden brown and clear yellow, very bright and attractive. They probably date from around 1320-30.

Some of the commercially produced Warwickshire designs retain thirteenth-century elements, but the majority are clearly of fourteenth-century date and include vine leaves, oak leaves and acorns, birds and other naturalistic motifs as well as grotesque figures and some heraldry.

The site of Ulverscroft Priory also yielded tiles of a different type usually associated with the Nottingham industries which date from the second half of the fourteenth century when the pottery industries were also flourishing in the town. These tiles are larger, harder fired and a darker colour than those made at Chilvers Coton. Heral- 76 dic motifs were popular. The remains of kilns associated with these tiles have been found in Nottingham itself and on the site of Lenton Priory now occupied by the University. One group has been recovered

76 *right*. Designs (133—143 mm square) associated with the Nottingham industry: three versions of the arms of Ferrers, one with a label of three points, each with three horseshoes, the badge of Ferrers. Later 14th century.

from the site of Beauvale Priory in Nottinghamshire, a Carthusian house not founded until 1343. Another group is known from Dale Abbey where a kiln was discovered in the nineteenth century. It is possible that some Nottingham-type tiles were made in Derbyshire also. Another Derbyshire kiln was found in Repton, but the tiles made there were different and included many with line-impressed decoration.

In the south-east a flourishing tile industry, also associated with a pottery industry, was established at Tyler Hill, Canterbury. Its products were small, well-made, hard-fired tiles tending to be slightly dished and to be purplish brown when glazed. They were used in Canterbury Cathedral and many other sites in the town and date from the last years of the thirteenth century. Many very well-made elaborately decorated tiles were being made in Hampshire 77 and West Sussex at the end of the fourteenth century.

Very little is known at present about the industries of the first half of the fifteenth century, and the designs of the Midland tiles that can be assigned to that period are generally poorer in quality than their fourteenth-century predecessors. In the middle of the century, however, there was a great revival of high quality, specially designed tiles made at Great Malvern for the Priory and for Gloucester Cathedral, and the impetus which this gave to the industry lasted until the middle of the sixteenth century in the regions of the lower Severn, Bristol and South Wales. The pavement 14 made at Great Malvern for Abbot Sebrok of 78 Gloucester is still in position before the high altar in the cathedral and one of the designs incorporates Sebrok's name and arms and the date 1455.

The contemporary work in the rebuilt

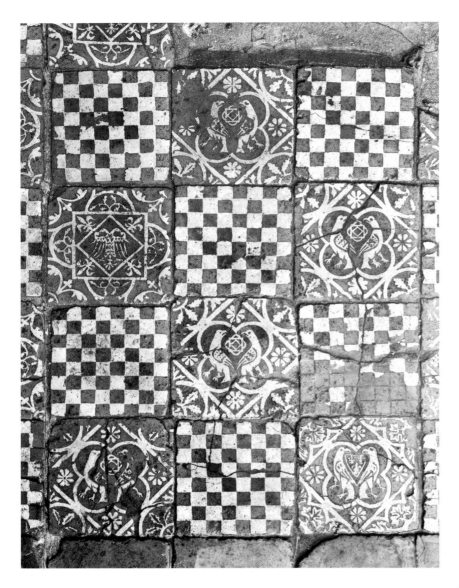

77 Part of the pavement of inlaid tiles (160 mm square approx.) *in situ* at Titchfield Abbey, Hampshire. 14th/15th century.

eastern arm of Great Malvern Priory was largely disturbed when the church was restored in the nineteenth century, but the tiles forming panels on the walls of the reredos are still present and the pavement of the sanctuary is a replica of the fifteenth-century original. It is not divided into panels and no plain tiles are included. Large numbers of the fifteenth-century tiles were retained and set in the wall of the ambulatory behind the high altar. Others were acquired by collectors and are now present in many museum collections. Three designs at Great Malvern include the dates 1453, 1456 and 36HVI (thirty-sixth year of the reign of Henry VI) which is 1458/9.

The Great Malvern tiles are large and thick, very well made with no keys in the base. The cavities stamped in the surface are shallow, and the white clay was introduced as a poured slip which clung to the edges of the cavities. The designs are intricate and their reproduction expert. They include along and legible inscriptions and beautiful foliage, rather feathery with squared-off ends.

Tiles decorated with the same stamps as those made at Great Malvern have been found in Warwickshire, Nottingham and York, as well as at many places in Worcestershire, and in Westminster Abbey of which Great Malvern Priory was a cell. A most interesting discovery was made on the site of Lenton Priory where underfired wasters decorated with Great Malvern designs were found in association with the remains of a kiln in 1950. This kiln was possibly the source of the tiles found in Nottingham and York. It certainly indicates that not all tiles decorated with Great Malvern stamps were made at Great Malvern itself, where two kilns associated with these tiles have been found and where the distinctive local clay was used.

78 *below.* A nine-tile design in Abbot Sebrok's pavement before the high altar in Gloucester Cathedral, published by Henry Shaw in 1858. It includes Sebrok's name, arms and the date 1455. The tiles, made at Great Malvern, are 140 mm square.

79 *right.* Part of the reredos in Great Malvern Priory with wall tiles of the 1450s.

80 *below right.* Design (138 mm square) used on Great Malvern tiles including the date 1456.

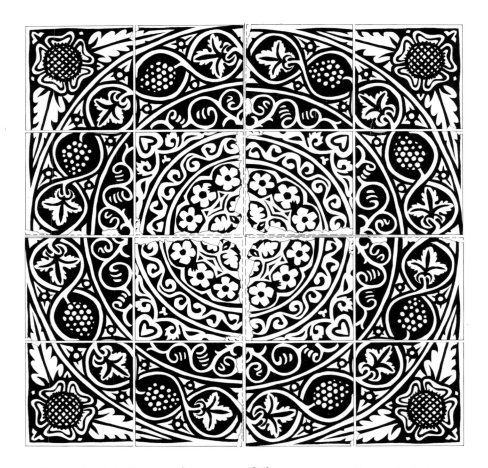

From about 1480 a very fine group of tiles was being made somewhere in the region of the lower Severn, but no kiln has yet been located. The pavement from ⁹ Canynges House, Bristol, already de-⁸¹ scribed, now displayed in the British Museum, belongs to this series as does the comparable pavement in the sanctuary of St David's Cathedral in Dyfed. This may have been reset with the best tiles from a larger area of paving. Comparable tiles from a pavement at Iron Acton (Avon) are exhibited in Bristol Museum.

Some tiles in this series were specially ⁸³ designed for St Augustine's Abbey, Bristol,

81 *above.* Sixteen-tile design present on tiles (125 mm square) in the Canynges pavement, now displayed in the British Museum. 15th/16th century. See also fig. 9, p.12.

82 *right.* Part of the panel of tiles (each 220 × 160 mm approx.) from Great Malvern Priory displayed in the British Museum. The top tile of this panel which is not illustrated has the date 36HVI (1558/9) along the top. The white clay was introduced as poured slip.

83 Four tiles (118 mm square approx.) from Gloucester Cathedral decorated with a design including the arms of John Nailheart and Robert Elyot, successive Abbots of St Augustine's, Bristol, from 1481 to 1515.

and include arms and rebuses of abbots and officials of the end of the fifteenth century and the early years of the sixteenth. The distribution of these tiles suggests that many, if not all, were made in or near Bristol.

A very fine set of tiles, all with heraldic 84 decoration, was designed for Edward Stafford, Duke of Buckingham, for use in Thornbury Castle, which was nearing completion when he was executed in 1521. Examples of these have been found at Thornbury and a number of other places in the neighbourhood, and in 1982 part of a pavement was found *in situ* at Thornbury Castle itself when a fallen tree was re-

84 *right.* Four-tile design made for Edward Stafford, Duke of Buckingham, for use in Thornbury Castle, Gloucestershire, shortly before his execution in 1521. It includes his arms, supporters, Garter and badges. Each tile 170 mm square.

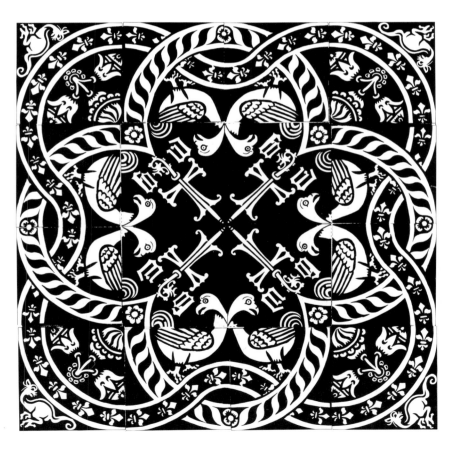

moved. Another specially designed heraldic series was made for Llanthony Priory, Gloucester. It can be dated to the early sixteenth century by the arms of Henry Deane as Archbishop of Canterbury, an office that he held from 1501 to 1503, and those of William Parker, who was Abbot of Gloucester from 1514 to 1539.

Perhaps the latest and most beautiful of the tiles of this area are those made for Hailes Abbey, probably in the second quarter of the sixteenth century. The known designs include the names of Anthony Melton who was Abbot of Hailes from 1509 to 1527 and of his predecessor Thomas Stafford. The other designs are all heraldic including the double-headed eagle displayed of Richard of Cornwall, the royal arms, the Tudor rose, the Beaufort grill and the pomegranate of Catherine of Aragon. This suggests a date earlier than 1533, when Henry VIII divorced Catherine, for the design of these tiles. In the eighteenth century Ralph Bigland, Garter King of Arms, recorded the heraldry that he saw on tiles of this type in the manor at Southam de la Bere, including the arms of Thomas Segar, last Abbot of Hailes. Unfortunately no example is present among the remaining tiles from Southam now in the British Museum or the site museum at Hailes Abbey. No plain glazed tiles seem to have been produced. The tiles are very well made, the cavities are shallow and the

85 *above left.* Two 16th-century heraldic designs: (*left*) Rhys an Thomas, Lord of Carew, d.1525, present in Carew Cheriton church; (*right*) Henry Deane, Archbishop of Canterbury, 1501–3, present on tiles from Llanthony Priory, Gloucester. 172 × 120 mm and 144 mm square.

86 *left.* Sixteen-tile design including the rebus of Thomas Stafford, Abbot of Hailes from 1483 to 1503, present on tiles (145–150 mm square) from Hailes Abbey and Southam de la Bere. Second quarter of the 16th century.

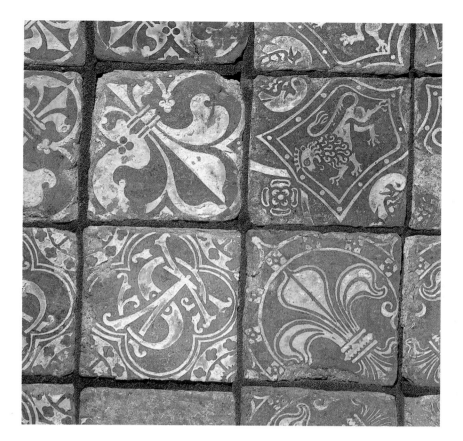

87 Tiles (145—150 mm square) from Southam de la Bere, Gloucestershire, assembled and displayed in the British Museum. Second quarter of the 16th century.

fetterlock of the Percys, the initials of John Darnton, Abbot of Fountains from 1478 to 1494, the arms of Fountains Abbey, and the 88 arms and motto of Marmaduke Huby, Abbot of Fountains from 1494 to 1526. The designs themselves are less competent than those of the Great Malvern, lower Severn and Hailes series, but it is the transference of the designs to the tiles that is so poor. This is due in part to the coarse texture of the tile body which makes the outline of the design rough, especially as the cavities are extremely shallow, and partly to the very thin layer of white clay used. The glaze on the other hand has a very high gloss, the tiles are fully oxidised and the background colour is a rich brown, but the yellow decoration is patchy

Both the design and execution of the decoration on a series of tiles made at Little 7 Brickhill in Buckinghamshire during the last decades of the fifteenth and early in the sixteenth century are very poor indeed, but the tiles themselves are well made and fired, and strangely the glaze, which looks purplish brown and yellow with patches of brilliant green, provides a colourful surface to the pavement. Two areas of paving laid with these tiles have been found *in situ*, one in a chapel at Bradwell Priory, the other in the nave of the church at Great Linford. In each piece of pavement only two or three different decorative designs are present and there are no plain tiles.

The latest two-colour tiles to which a date can be assigned were made for William Sharington, the first lay owner of 89 Lacock Abbey in Wiltshire, between 1550 and 1553. The majority of these were decorated with designs derived from those of the lower Severn series but at least two designs were specially made. These include renaissance motifs and the scorpion and initials of Sharington and his third

white clay was introduced as a liquid slip which clung to and lipped the edges of the cavities. The designs are beautifully drawn, the work of an expert, perhaps one of Henry's own painters or one of the heralds, and the man who carved the stamps and the man who made the tiles were equally skilled, so that the designs were faithfully reproduced.

The abbots of Fountains were not so fortunate. A fairly widely distributed series of two-colour tiles was being made, almost certainly in York itself, probably in the late fifteenth century and certainly in the early part of the sixteenth. The designs include four- and nine-tile groups including the

88 *left*. Four-tile design including the arms and motto of Fountains Abbey, used on tiles (140 mm square) from Fountains and Rievaulx Abbeys, Yorkshire. Probably made in York. Earlier 16th century.

89 *below left*. Two designs (130 mm square) made for William Sharington, first lay owner of Lacock Abbey, Wiltshire, between 1550 when he married his third wife Grace, whose initial is here linked with his, and 1553 when he died.

90 *right*. Panel assembled and displayed in the British Museum with tiles (130 mm square) from St George's Church, Fordington, Dorset, and a heraldic tile of unknown provenance. Probably first half 16th century

wife. The design is excellent and all the tiles are well made and neatly decorated. It would seem that in the later fifteenth century and in the first half of the sixteenth century expert tilers were concentrated in the south-west, and although the manufac-⁹⁰ ture of tiles was good the art of decorating by the two-colour process had seriously declined in the Midlands and the north.

Few if any two-colour tiles are known to have been made after the 1550s. With the spread of new architectural ideas from Italy to England decorated tile pavements went out of fashion. Present evidence suggests that in the south-east they had already done so early in the fifteenth century and that new tile pavements in that region were laid with plain glazed tiles ⁹¹ in two or more colours. Many of these plain glazed tiles were imported from the Netherlands during the later fourteenth, fifteenth and sixteenth centuries. By the end of the sixteenth century important buildings were being paved with large black and white marble and stone quarries. Plain glazed tiles were still made, indeed production has continued until the present day, but they were generally used in the less important parts of buildings.

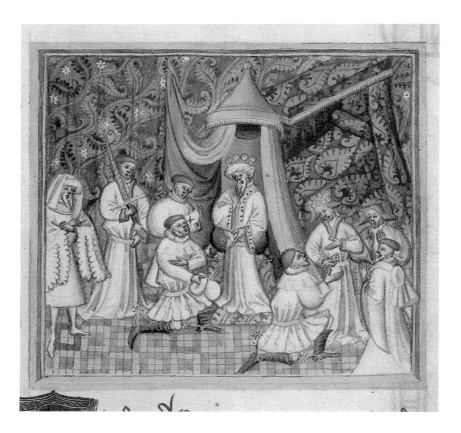

91 Miniature painting, including a pavement of plain glazed tiles, depicting the presentation of Offa's ring to St Edmund. Lydgate's *Life of St Edmund in English Verse*, British Library MS Harleian 2278 f. 23.

With the revival of interest in Gothic architecture in the nineteenth century vast numbers of replicas of decorated medieval tiles were made, two-colour types being the most popular. Very few Gothic buildings that were restored or neo-Gothic buildings that were constructed were without replicas of medieval tile pavements, some of them of considerable interest.

It seems that although decorated tile pavements were occasionally laid in England from the tenth century onwards it was not until the 1330s that decorated tiles began to be produced regularly and in increasing quantities. It seems most probable that at first the tiles were designed and made for a particular location and that manufacture took place at or near the place where they were to be used but that by the 1250s commercial tileries were already being established. The products of these tileries were sold at so much a thousand to any purchaser who could pay for them and they seem to have been within the means of humble churches and any layman who could afford a craftsman-built house. Although in the period of disruption following the Black Death even the king's clerks of works were buying commercially produced tiles, at most other times customers who wished to have a specially designed, higher quality pavement could probably find a tiler who could make some better tiles, and some of the later fifteenth-century and sixteenth-century examples are very fine. Many of the commercially produced tiles were well made and the decoration was satisfactory and even those tiles that were technically and artistically inferior provided a colourful, hard-wearing and flat floor that remained popular until the middle of the sixteenth century.

Further reading

The most extensive published bibliography and discussion of English medieval tiles are in the writer's catalogue of tiles in the British Museum listed below. A large number of articles are contained in national and local archaeological and antiquarian periodicals. A selection of the most useful books and papers is listed below.

General

NICHOLS, JOHN GOUGH, *Examples of Decorative Tiles, sometimes termed encaustic*, London, 1845.

SHAW, HENRY, *Specimens of Tile Pavements*, London, 1858.

WARD PERKINS, J. B., 'English Medieval Embossed tiles', *Archaeological Journal*, Vol. XCIV, 1937.

Catalogues

EAMES, ELIZABETH S., *Catalogue of Medieval Lead-glazed Earthernware Tiles in the Department of Medieval and Later Antiquities, British Museum*, London, 1980.

LANE, ARTHUR, *A Guide to the Collection of Tiles*, Victoria and Albert Museum, London, 1939, 2nd edn 1960, chs III and IV.

WARD PERKINS, J. B., *London Museum Catalogues, No. 7 Medieval Catalogue*, London, 1940.

Regional

CHATWIN, PHILIP B., 'The Medieval Patterned Tiles of Warwickshire', *Transactions of the Birmingham ... Archaeological Society*, Vol. LX (1936), pub. 1940.

EAMES, ELIZABETH, 'The Products of a Medieval Tile Kiln at Bawsey, King's Lynn', *Antiquaries Journal*, Vol. XXXV, 1955. 'The Canynges Pavement', *Journal of the British Archaeological Association*, Vol. XIV, 1951. 'A Tile Pavement from the Queen's Chamber, Clarendon Palace, dated 1250-2' ibid., Vols XX, XXI, 1957-8. 'A Thirteenth-century tile pavement from the King's Chapel, Clarendon Palace', ibid., Vol XXVI, 1963.

EAMES, ELIZABETH, and KEEN, LAURENCE, 'Some line-impressed mosaic from western England and Wales', *Journal of the British Archaeological Association*, Vol. XXXV, 1972.

EMDEN, A. B., *Medieval Decorated Tiles in Dorset*, Chichester, 1977.

GREENFIELD, B. W., 'Encaustic Tiles of the Middle Ages ... in the South of Hampshire', *Proceedings of the Hampshire Field Club*, Vol. II, Part II, 1892.

HABERLY, LOYD, *Medieval English Pavingtiles*, Oxford, 1937.

HOHLER, CHRISTOPHER, 'Medieval Pavingtiles in Buckinghamshire', *Records of Buckinghamshire*, Vol. XIV, 1942.

KEEN, LAURENCE, 'A Series of 17th- and 18th-century lead-glazed relief tiles from North Devon', *Journal of the British Archaeological Association*, Vol. XXXII, 1969.

KNAPP, G. E. C., 'The Medieval Paving Tiles of the Alton area of N.E. Hampshire', *Proceedings of the Hampshire Field Club and Archaeological Society*. Vol XVIII, 1954.

LEWIS, J. M., *Welsh Medieval Paving Tiles*, Department of Archaeology, National Museum of Wales, 1976.

SHURLOCK, MANWARING, *Tiles from Chertsey Abbey, Surrey, representing early romance subjects*, London, 1885.

WHITCOMB, NORMA, *The Medieval Floor-Tiles of Leicestershire*, Leicester, 1956.

Kilns

DRURY, PAUL J., and PRATT, G. D., 'A late 13th- and early 14th-century tile factory at Danbury, Essex', *Medieval Archaeology*, Vol. 19, 1975.

EAMES, ELIZABETH, 'A Thirteenth-century Tile Kiln Site at North Grange, Meaux, Beverley, Yorkshire', *Medieval Archaeology*, Vol. V, 1961.

GARDNER, J. S., and EAMES, ELIZABETH, 'A Tile Kiln at Chertsey Abbey', *Journal of the British Archaeological Association*, Vol. XVII, 1954.

MYNARD, DENNIS C., 'The Little Brickhill tile kilns and their products', *Journal of the British Archaeological Association*, Vol. 38, 1975.

RICHARDSON, J. S., 'A Thirteenth-century Tile Kiln at North Berwick, East Lothian ...', *Proceedings of the Society of Antiquaries of Scotland*, Vol. LXIII, 1928-9.

VIDLER, LEOPOLD A., 'Floor Tiles and Kilns near the site of St. Bartholomew's Hospital, Rye', *Sussex Archaeological Collections*, Vol. LXXIII, 1932.

Places to visit

Select places where medieval tiles can be seen in their original position or re-set

Byland Abbey, Yorkshire: church, cloister and site museum
Canterbury Cathedral, Kent
Carew Cheriton Church, Dyfed
Chester Cathedral, Cheshire
Cleeve Abbey, Somerset: old refectory and church
Clifton House, King's Lynn, Norfolk
Ely Cathedral, Cambridgeshire
Ely, Cambridgeshire: Prior Crauden's chapel
Fountains Abbey, Yorkshire: church and site museum
Gloucester Cathedral, Gloucestershire
Great Linford Church, Buckinghamshire
Great Malvern Priory, Worcestershire
Higham Ferrers Church, Northamptonshire
Horwood Church, North Devon
Icklingham All Saints Church, Suffolk
Launcells Church, Cornwall
Milton Abbas, Dorset: St Catherine's chapel
Muchelney Church, Somerset
Newton St Petroc Church, North Devon
Old Byland Church, Yorkshire
Old Radnor Church, Powys
Rievaulx Abbey, Yorkshire: church, frater and site museum
Rochester Cathedral, Kent
St David's Cathedral, Dyfed
Shaftesbury Abbey, Dorset: church and site museum
Stokesay Castle, Shropshire
Stokesay Church, Shropshire
Strata Florida Abbey, Dyfed
Tewkesbury Abbey, Gloucestershire
Titchfield Abbey, Hampshire
Wells Cathedral, Somerset
West Leigh Church, North Devon
Westminster Abbey: Chapter House and St Faith's chapel
Winchester Cathedral, Hampshire
Winchester, Hampshire: Hospital of St Cross

Places with interesting replicas of medieval pavements

Great Malvern Priory, Worcestershire
Rochester Cathedral, Kent
St Alban's Abbey, Hertfordshire
Salisbury Cathedral Chapter House, Wiltshire
Winchester Cathedral, Hampshire

Select list of museums with displays of medieval tiles

British Museum, London
Bedford Museum, Bedfordshire
Birmingham City Museum and Art Gallery, West Midlands
Cheltenham Museum, Gloucestershire
Chertsey Museum, Surrey
Grosvenor Museum, Chester, Cheshire
Guildford Museum, Surrey
Hailes Abbey Site museum, Gloucestershire
Lacock Abbey, Wiltshire
Muchelney Abbey site museum, Somerset
Norton Priory Museum, Runcorn, Cheshire

St Ives Museum,
Cambridgeshire
Salisbury Museum,
Wiltshire
Thornton Abbey site
museum, Humberside
Victoria and Albert
Museum, London
Weybridge Museum,
Surrey
Yorkshire Museum, York

Most county and town
museums display some
medieval tiles

Index

Illustration Acknowledgements

The author and publishers are
grateful to the following for
permission to reproduce
illustrations:

Photographs

David Baker 71; James Barfoot
10, 18, 19, 21, 22, 34, 36, 43, 47,
51, 67, 72, 78; British Library
Photographic Service 4, 41, 91;
British Museum Photographic
Service (mainly the work of
Anthony Milton) *front and
back covers, title page, pp. 2-3,
13, 17, 24, 25, 27, 29, 32, 44, 45,
58, 61, 62, 69, 75, 82, 83, 87, 90*;
John Charlton 5; Commission
for Historic Buildings and
Monuments 15, 49, 54, 77;
Thomas Fanning 40; M.O.
Miller 9.

Drawings

John Bailey 1, 7, 35, 70, 85;
Kenneth Beaulah 16; British
Museum, Department of
Medieval and Later Antiquities
(*Catalogue of Medieval Tiles*,
Elizabeth Eames) 2, 7, 26, 28,
30, 38, 39, 42, 46, 48, 55, 56, 57,
59, 60, 64, 76, 80, 81, 84, 85, 88,
89; L.S. Colchester 66; Paul
Drury 6; M.O. Miller 8, 86;
Rosemonde Nairac 18, 50, 57;
Olive Temple 53, 57; Shirley
Walker 34.

The author retains the
copyright in photographs 3, 11,
12, 14, 20, 23, 31, 63, 65, 68, 73,
74, 79; and in drawings 7, 18,
33, 35, 50, 52, 53, 57, 70, 85.
Baker, Barfoot, Beaulah,
Charlton, Colchester, Drury,
Fanning and the Commission
for Historic Buildings and
Monuments retain the
copyright in the illustrations
listed beside their names
above.